# STORE WINDOWS

No. 15

# STORE WINDOWS

## No. 15

Martin M. Pegler

Visual Reference Publications Inc., New York, NY

Visual Reference Publications, Inc.
302 Fifth Avenue
New York, NY 10001

Distributors to the trade in the United States and Canada
Watson-Guptill
770 Broadway
New York, NY 10003

Distributors outside the United States and Canada
HarperCollins International
10 East 53rd Street
New York, NY 10022-5299

Book Design: Judy Shepard

Library of Congress Cataloging in Publication Data:
Store Windows No. 15

Printed in China

ISBN: 1-58471-108-6

# CONTENTS

# P.S. Martin M. Pegler:
# ON SEDUCTION

"Shopping is an art; an art of seduction, designers will tell you. The tricks of the trade—the soothing architecture of the store, the mannequins, the display cases bathed in golden light—are all employed to tempt the consumer."

Thus began a brief article in a recent edition of *Shopping Center World* that told about an exhibit at the Tate in Liverpool, England. The exhibit is titled "Shopping: A century of art and consumer culture." I have not seen the exhibit and the article—really an announcement—offers only tidbits to whet one's appetite since the exhibit focuses on the relationship between the displays and consumption of commodities and contemporary art. I would, however, like to go back to those very first words—"Shopping is an Art; an art of seduction" and use it for my own point of departure.

The two important words here are "art" and "seduction." "Art"—when referring to shopping—could be defined as "the principles and methods of governing any craft" and "the exceptional skill in conducting any activity" (*Random House Dictionary*). We are not, necessarily, referring to "aesthetic principles" but we are talking about what is beautiful and appealing and how to get that message across to the designated target market. "Seduction" is all about "persuasion and inducement." It is "winning over," "attracting," and "enticing." Thus, seduction is about tempting and alluring shoppers to buy by the presentation of product. Unfortunately, too often the retailer forgets that shoppers need to be seduced. They do need to be made love to—to be made to feel special and wanted—to be stroked and pampered and treated with regard and affection. You cannot take them for granted anymore—not in this highly fickle and competitive society. Of course, there are certain products that

sell themselves because they may be part of our essential needs like food staples and basic cover-up garments. Sometimes all it takes to sell a product is a very low price or a discount for volume; a matter of economy. But, when it comes to those items that the shopper can live without but would rather not because those "unnecessary" things are what add richness, color, texture and definition to that shopper's lifestyle—then it does take the "art of seduction" to sell the "luxury" product. Whatever isn't necessary or basic is a luxury! Luxuries—whether they are an extra scarf, a new tie, a bottle of scent, a Mercedes Benz or a Rolex watch with

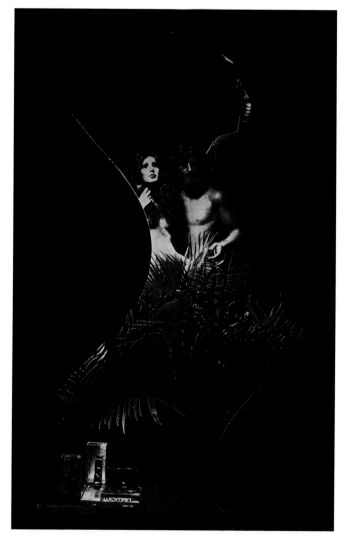

diamonds—they all need to be sold and that kind of selling takes persuasion and enticement.

Over and over again, knowledgeable people in the retail industry refer to the display element as a vital part of selling. Promotion is very important, but promotion works best when combined with presentation. Presentation is more than just showing or revealing; it involves all of the art of seduction to make the product gleam and shimmer and shine and to appear as enticing and alluring as possible. That is what display does and that is what display is all about. Yes! Display is an art!!

Many, many years ago when I was younger and often called upon to speak to groups of retailers around the world, I would often start my presentation with this story. It has been some time since I have told it and I think it is now even more relevant than it was then—so here goes.

Once—a long, long time ago— way before the days of video, *Vogue* and individual lifestyles—there existed a land that is no more. The sky was blue, the trees were green and the sun was visible and golden. The foliage was rich and thick and the trees were laden with ripening fruits and everything was real—genuine. Not a single leaf was plastic and the lush carpet of grass was also real; no astro turf, no indoor-outdoor carpeting, no plastic matting. In this bird and animal filled, smog-free, pollution-free and almost completely people-free garden lived an underdressed, over-exposed, and fruit diet restricted pair. They were the original suburbanites—Adam and Eve.

And what does one do on a bright, lazy and carefree day in Paradise? One goes down into the garden to sort of shop around; nothing serious—just browsing. Now we come upon our heroine—Eve— breathing a phrase as ageless as Time: "I don't have a thing to wear." Only she means it! The next character in

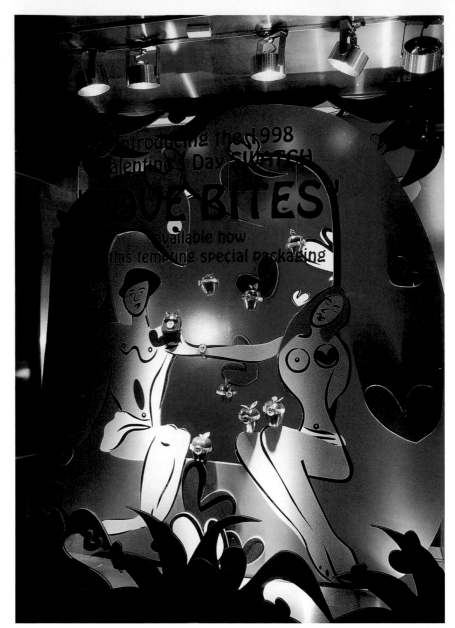

our evolving retail soap opera is the snake, a.k.a. the first salesperson. He has got an apple to sell. He doesn't take credit cards or personal checks. He doesn't gift wrap or deliver. He doesn't advertise. His only competition is way, way up in the heavens. So—surrounded by hundreds of varieties of exotic and luscious fruits, how do you sell a single red apple— which just so happens to be forbidden? First he polishes and buffs it till the skin shines with a satin luster. Then he sets it amidst the greenest of the green leaves which set off the brilliance of the red color. He accessorizes the apple with a dew drop or two and then angles it, arranges it and drapes it just so— so that the

sun's rays strike it and catch it and set the dew drops sparkling like diamonds. The little brown soft spot is hidden in back—lost in the leaves. He fans in the scent of apple blossoms and the gentle breeze kisses the branches and makes the apple dazzle in reflecting highlights. The snake has appealed to all of Eve's senses— touch—smell—sight and the "taste" part is sure to follow. To this sensual appeal he has added mystery, illusion, a sense of danger and the desire to obtain the unobtainable. There is just enough "sin" in this seduction to make that first bite worthwhile.

Well, you all know how this story ended. Eve was hooked. She was enticed, lured and snared. She was

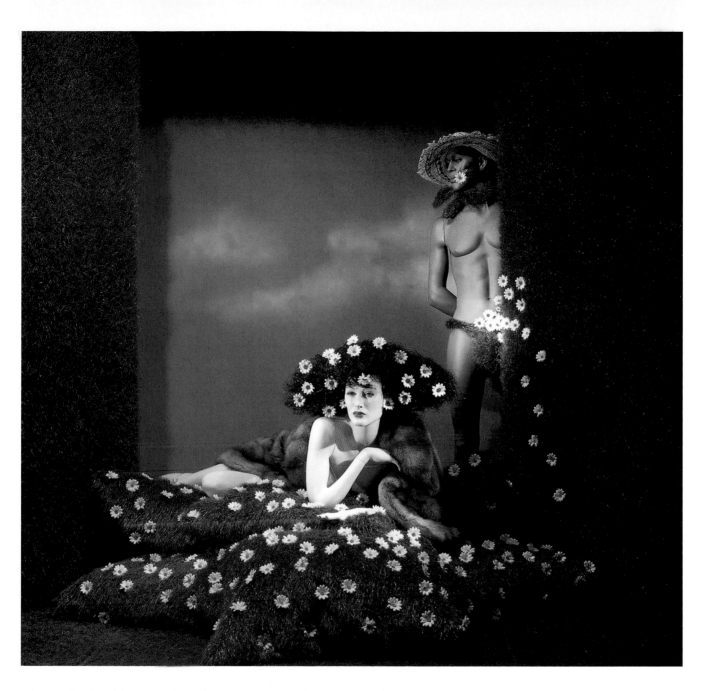

taken in by the alchemy and art that was first practiced by the salesman/ snake and that has since become the basic handbook for visual merchandisers and displaypersons. If it weren't for the devilishly clever snake, not only would we not be eating all those wonderfully delicious apple dishes—there would be no garment industry, no fashion designers, no retailers, no clothes to put on so that we can look as though we are falling out of them.

An interesting footnote to this little story: Though Eve bit into and bought into the whole apple thing, it was she who picked out the first fig leaf for Adam. It may have been a

question of size—or maybe it was just impulse shopping.

And so that is what the Art of Seduction or Display is all about. It is about attracting the shopper—bringing her closer—exciting her with something new and different presented in a new and different way, and creating a shopping experience enhanced by the lighting, the color, the contrasts and the textures, the unique props and the placement of the product. It is the fine art of temptation; showing only the very best in the very best way so that all the competition is left behind and forgotten. It means stamping the product with the retailer's own unique

style and image and presenting merchandise to suit the lifestyle of the targeted shopper. It means learning and knowing the craft and delivering that knowledge with style and the right amount of razzle dazzle. It is all about show-manship!

I'm sorry that I won't get to see that exhibit at the Tate but I am glad that I had this chance to take off and talk about the idea behind the exhibit.

All the best—till next month

Martin M. Pegler
mmpegler@optonline.net

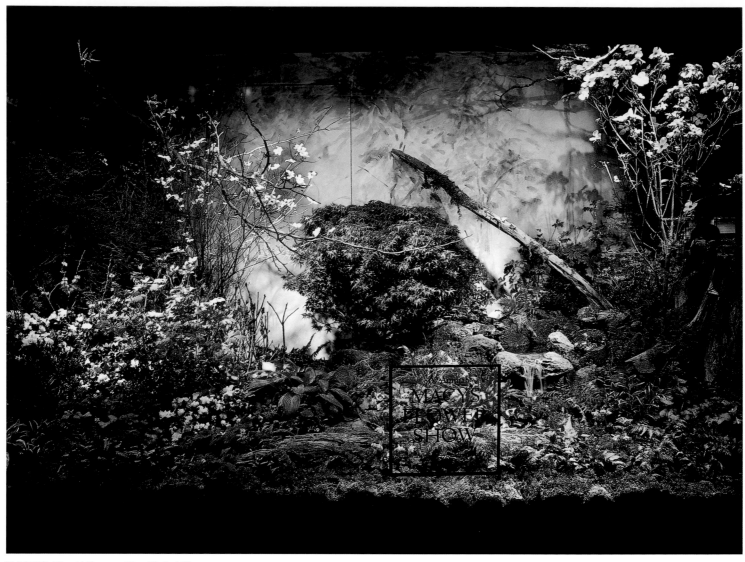

**MACY'S,** Herald Square, New York, NY
DESIGN: **Sam C. Joseph**, Creative Director

Spring would not be spring in New York without Macy's annual Flower Show. Every year the display staff works hard and plans months in advance to make the next year's Flower Show bigger, better and more spectacular than the last year's. They turn the whole store into a well cultivated and flourishing garden. Though some of the trees and larger plants return year after year—after a "rest" in between in an up-state nursery—the concern is about getting the flowering plants to bloom—blossom and burst out in full floral beauty on the show's scheduled dates.

This flower show, the store's 30th, featured over 30,000 different species from six continents.

"Water in all its forms is central to this year's garden; bouncing streams, ponds, rain, fog and a monumental topiary umbrella as a centerpiece."

Illustrated here are three of the major garden windows. In one a stream flows slowly over the top of a rock to become a gentle waterfall that trickles down to the window. Another is anchored by an old well and the third has water gushing forth from renaissance sculpted heads into the stone basins below.

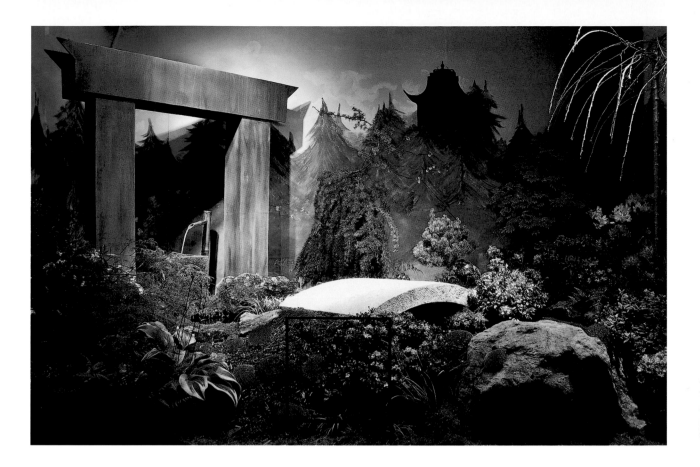

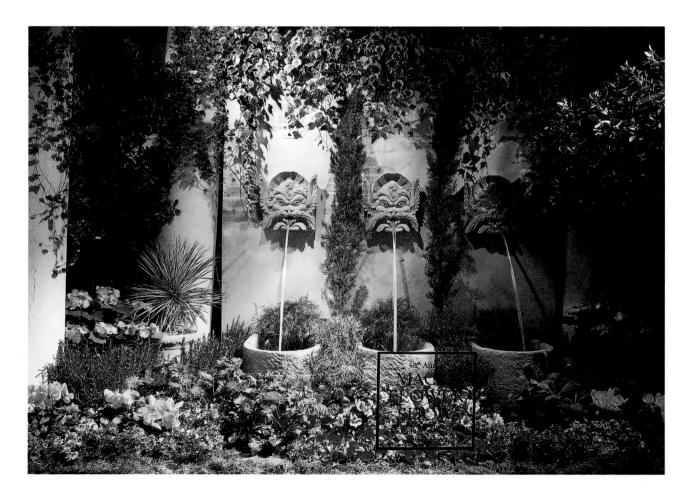

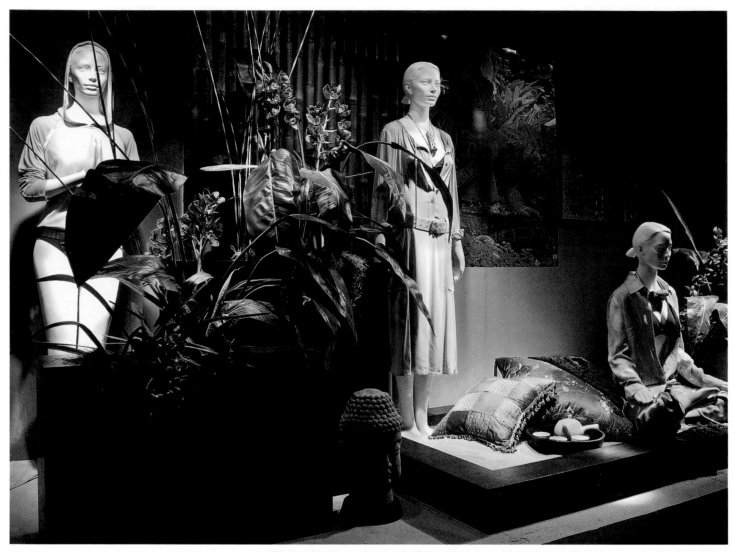

**MACY'S,** Herald Square, New York, NY
DESIGN: **Sam C. Joseph**, Creative Director

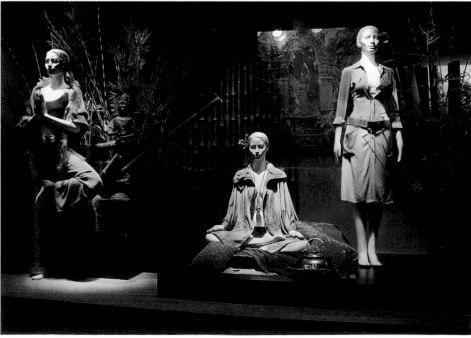

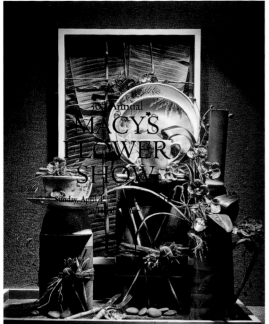

The long battery of windows—including the numerous shadow box display cases—on W. 34th St. carried through the theme. Where the Broadway "garden" windows were purely "institutional" or "good will" windows—devoid of any merchandise, all of the 34th St. windows featured some of Macy's assortment of Spring into Summer fashions and accessories.

Among the features of the flower show was the over 1000 orchids that appeared inside the store in the Exotic Orchid Garden. The exotica of the East plus the variety of the orchids took over these windows where semi-realistic mannequins in tranquil, yoga-like poses rested on cushioned platforms. They shared the space with panels of green bamboo, Eastern sculptures and decoratives, and—of course—the orchids.

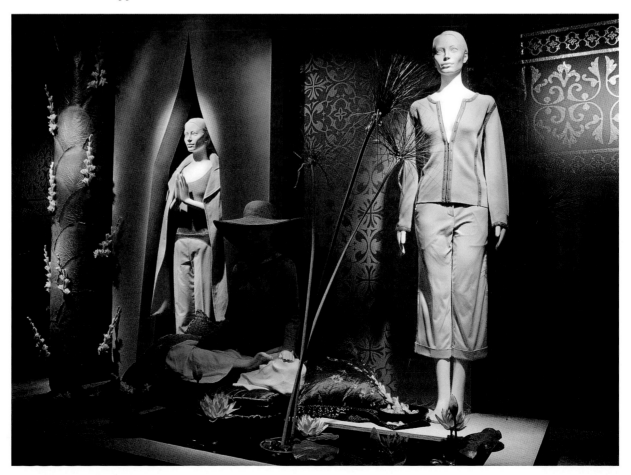

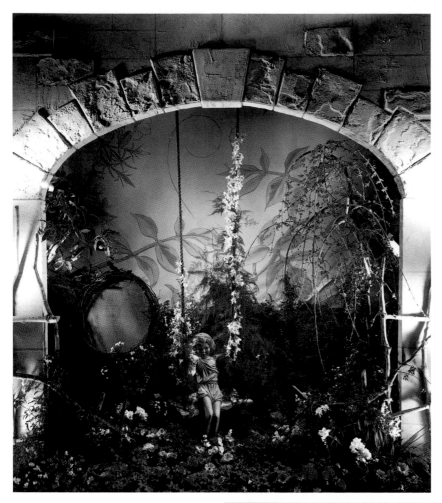

Each year we feature a Flower Show to open our selection of Spring/Easter promotional displays. This year we are pleased to show the windows and interiors of Marshall Field's famous State St, store in Chicago where Amy Meadows and her talented staff have created a fantasy land based on a children's story—The Flower Fairies—published in 1923. The book was written and illustrated by Cicely Mary Barker and the illustrations served as the inspiration for the displays.

The simple story served to hold together the thousands of blossoming plants and bushes that filled the State St. windows as well as the ledges inside the store. The Flower Fairies appeared in all the venues. This classic early 20th century edifice has two atria and we are showing how with some variations the theme was carried through in these vast, multi-level spaces. Fountains, gazebos, topiary, branches, swags and drapes—and the flower fairies appear throughout to tell the story.

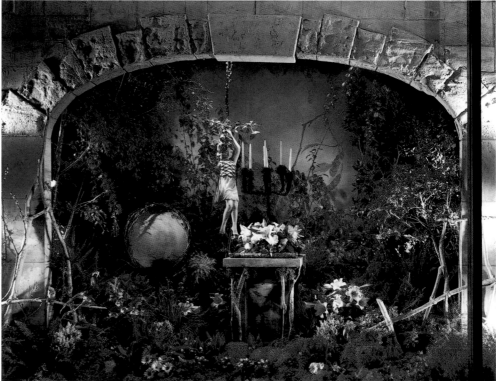

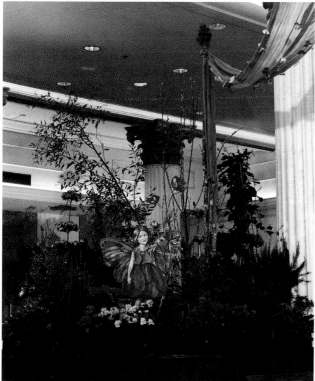

**MARSHALL FIELD'S,** State St., Chicago, IL
CREATIVE DIR./VISUAL MARKETING, TARGET: **Jamie Becker**
VISUAL MARKETING MANAGER, STATE ST.: **Amy Meadows**
PHOTOGRAPHY: **Susan Kezon**

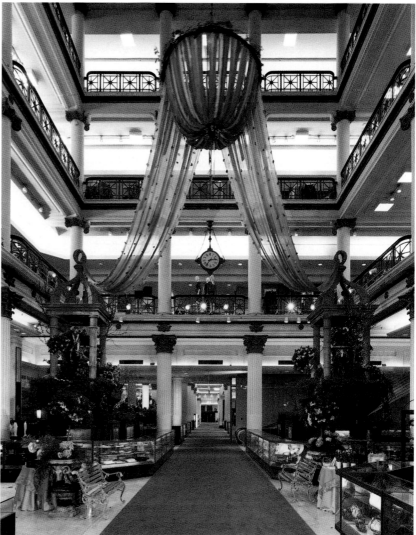

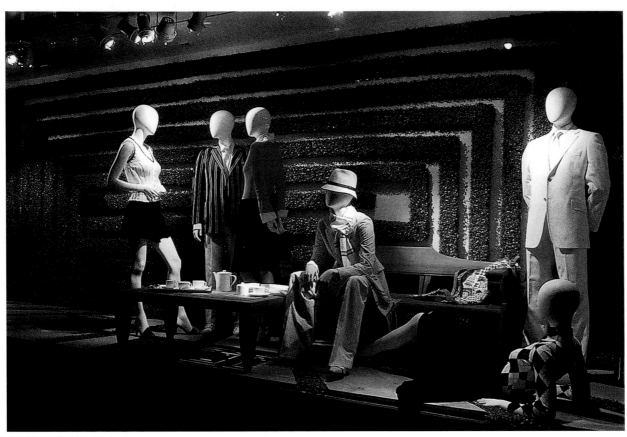

**BURBERRY,** New York, NY

One of the first signs of spring is the growth of grass—the green sprouts that crop up and pop up between the patches of melting snow and the grimy cracks in city sidewalks. In a more sophisticated, stylized and stylish way, grass, grass mats and plastic greenery appear in displays to herald the arrival of the spring season.

A formal English garden takes over the rear wall of the very English Burberry store. The garden defies gravity's pull as it stretches out to set the scene for the smart fashions. Note the grass growing between the angled floor pads that are laid to further enhance the setting with forced perspective—adding a feeling of greater depth to the window.

The Bay uses "grass" matting to upholster a Louis XV chair as well as create a checkerboarded floor pattern with square of grass alternating with squares of pebbles.

**THE BAY,** Toronto, ON, Canada

Coach frames the white picket fence/ gate that leads to the new fashion scene with the green stuff. Here, too, the plastic material is clipped and cropped to a textured finish. The display niches in hot pink not only contrast with the greenery but accentuates the pink fashion accessories. In another Coach window the garden gate theme carries through but here the greenery covers the pup turning it into an animal "topiary." The pebble ground cover add another texture to the settings.

Crate & Barrel sprouts the real thing in buckets, pots and tins to add lively green accents to the window featuring "Seeing Green" for household items.

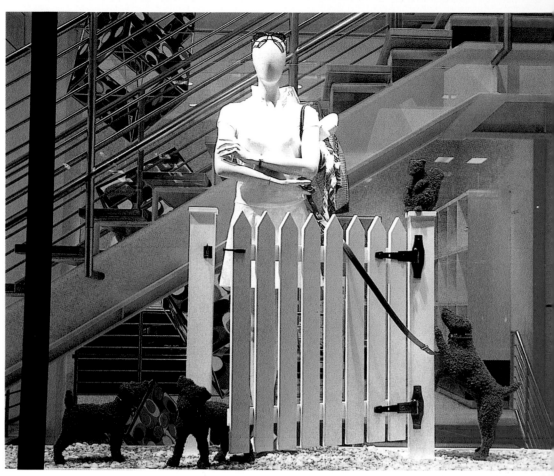

ABOVE AND RIGHT
**COACH,** New York, NY

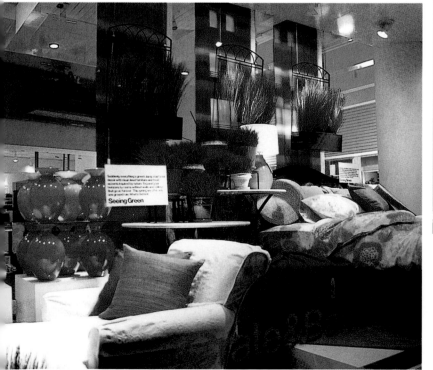

**CRATE & BARREL,** New York, NY

**SAKS FIFTH AVENUE,** New York, NY

**ANN TAYLOR,** Madison Ave., New York, NY

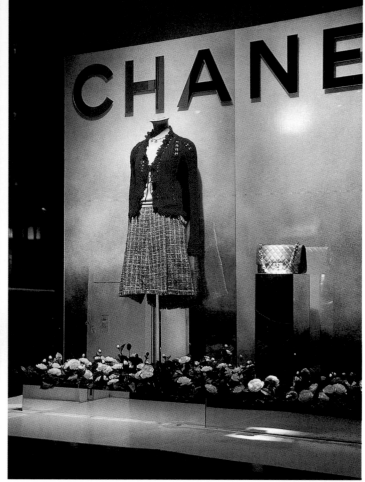

**CHANEL,** Fifth Ave., New York, NY

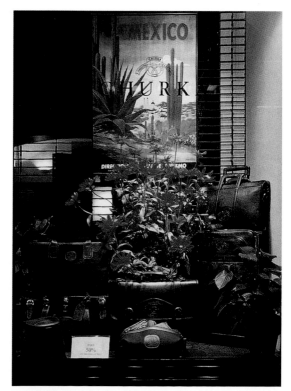

**GHURKA,** W. 57th St., New York, NY

**TARYN ROSE**, New York, NY

Flowers blossomed all over the city—bursting through the concrete and mock gardens set in these glassed-in windows to proclaim the Spring season and to complement the new fashions. In some cases it was a single flower in a shadow box, a line of flowers in long necked vases stretching across the window or being nurtured in clear glass containers along the glass line.

Chanel grew her signature white gardenias in planters on the floor while Ann Taylor used potted narcissus plants to play up the store's collection of lime green coordinates. Ghurka went all the way with a giant bunch of black-eyed susans that brightened up and lightened up their luggage presentation.

**SCHREIBMEISTER,** Munich, Germany

Gert Mueller of Munich filled straw baskets with colorful bouquets of flowers in his Schreibmeister window to set a seasonal look for the stationery items laid out below. Bendel brought in several just-beginning-to-blossom branches and set them out on the green grass mat in the open back window. The outdoor garden was enhanced by the "white picket fence"—in forced perspective—that added a sense of depth to the display area.

Bloomingdale's rose bush grew thick and lush with red and pink flowers. It stood next to a series of opening doors—all open to the new season and the new fashions

making an entrance.

Flower heads—oversized and outrageous in scale—were applied in a random manner on the acrylic panels to make the blossoms look as though they were floating in mid air. Some seem to have landed on the way-out white spun glass wigs worn by Vertigo's mannequins.

Saks applied their gigantic peony flowers in a more controlled design on the cerise back panel that complemented the flowers that were bursting forth on the print dress worn by the stylized mannequin.

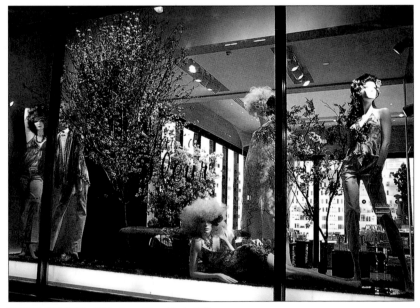

**HENRI BENDEL,** Fifth Ave., New York, NY

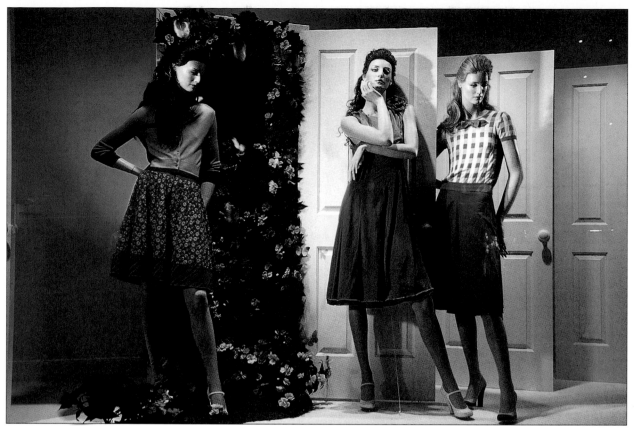

**BLOOMINGDALE'S,** Lexington Ave., New York, NY

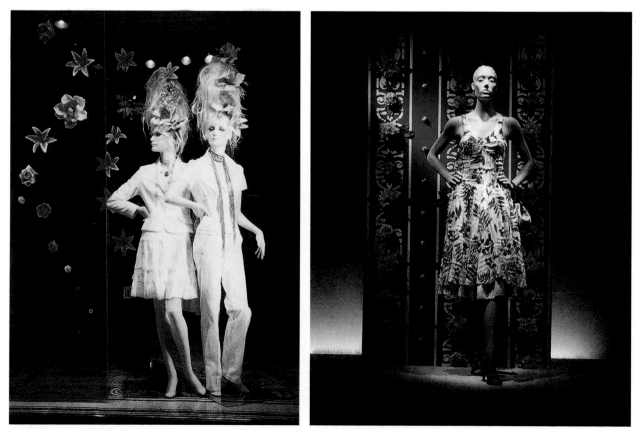

**VERTIGO,** New York, NY

**SAKS FIFTH AVENUE,** New York, NY

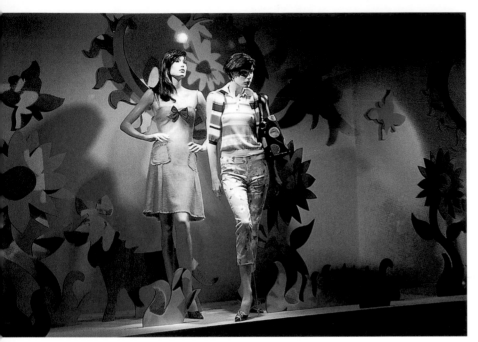

ABOVE AND BELOW
**BLOOMINGDALE'S,** New York, NY

A rose is a rose is a rose and a flower—whatever it smells like—is Spring! Real, artificial, live, plastic, silk or paper—normal size or oversized—if it looks anything like a flower it means Spring is here.

Bloomingdale's is into overstatements! Bigger is better and stylized is just right for these trendy fashions. Cut out or appliquéd, these bright, strong colored and almost childishly naive flowers bring the Spring season into the windows and out onto the street.

At Coach, a see-through all-over floral print on clear vinyl is applied directly to the front glass with a giant opening left for the viewer to behold what spring has brought with it. The abstract is seated/balanced on a pink and white motor bike and the pink replays the pink accessories on view.

What is more of a harbinger of spring than the sunny yellow blossoms that break out on forsythia bushes as soon as the last cold spell disappears? Steuben clusters an armful of blooming branches into one of their elegant crystal vases to announce the season's arrival.

At Crate & Barrel the cherry blossoms are still in bud stage but they are willing—but waiting—to open up and add a blush of pink to the serene setting in aquas, greens and blues.

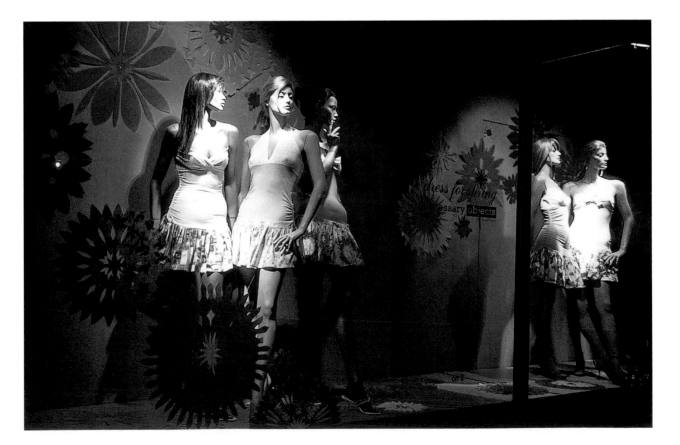

**COACH,** New York, NY

**CRATE & BARREL,** New York, NY

**STEUBEN GLASS,** New York, NY

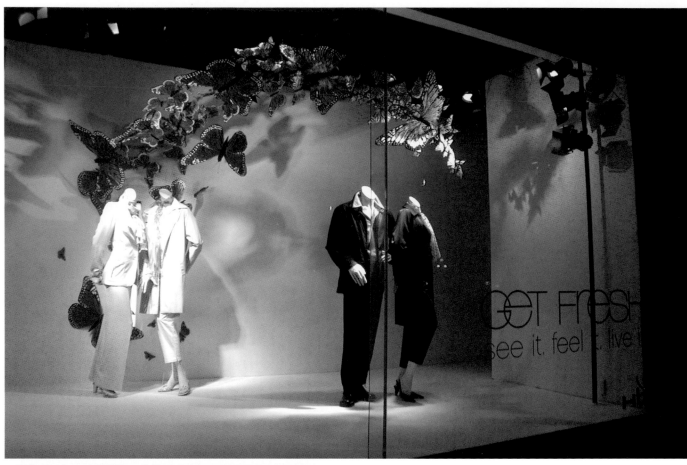

**THE BAY**, Toronto, ON

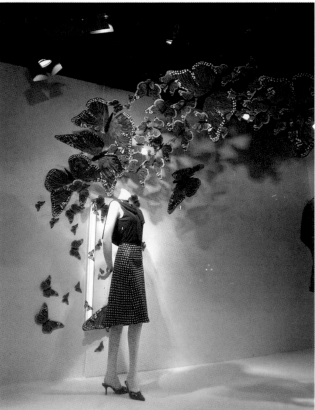

Maybe it's their color—the delicate tracery—the fluttering movement? Whatever! Butterflies are a sure sign of Spring and a great reference to color and color promotions.

Spring at The Bay in Toronto, as interpreted by Ana Fernandes and her staff, meant that it was time to wake up—freshen up—"see it. feel it. live it." Swarms of assorted size and colored paper butterflies in a swirl of action seemed to point up the way as they flew, floated and swept from window to window to get the "Get Fresh!" message across.

Butterflies, stenciled on the front glass and on the back wall, at Bloomingdale's literally surround the abstract mannequin armed with an oversized butterfly catching net.

Myriads of butterflies splattered the white walls of Saks Fifth Avenue for the presentation of delicately patterned pink-on-pink separates. Some of the outfits actually included butterfly prints. A warm pink glow of light added to the overall lovely effect.

**SAKS FIFTH AVENUE,** New York, NY

Ady Gluck Frankel for AQUA

on 2

**BLOOMINGDALE'S,**
Lexington Ave., New York, NY

25

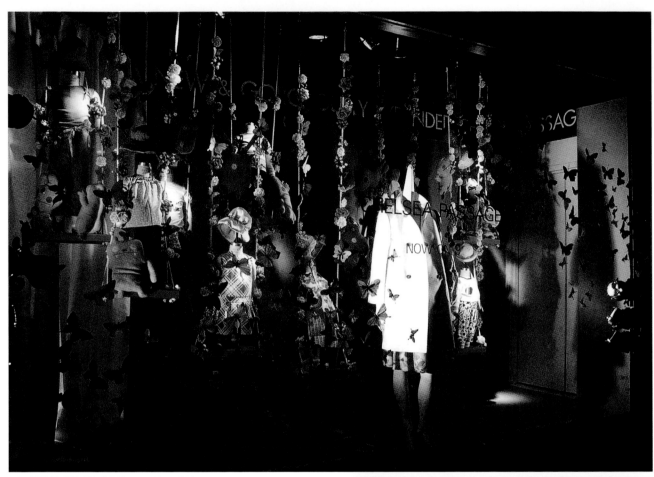

**BARNEYS NEW YORK,** New York, NY

Sure signs of spring are the 3 Bs: Birds, Bees & Butterflies.

At Barneys the butterflies have taken over and almost cover the children's outfits shown on stuffed figures positioned on swings. Colorful flowers and butterflies are entwined around the ropes that hold the swings and they also adhere to the front glass, the pink covered floor and the equally pink back wall. It is a sure sign of spring—and Easter as well.

Hundreds of butterflies in myriad colors, patterns and sizes hang from invisible wires in the Gucci boutique window in Sydney, Australia. The multi-colored storm forms around the eye-filling soft gray dress on the headless form in the otherwise neutral setting.

Tiffany's on Fifth Avenue samples butterflies and birds —in the form of plumage—in these attractive shadow box windows that feature the jewelry store's coral beads, a string of amber beads and some elegant china. The piece of textured bark and the antique birdcage add scale and substance to each arrangement.

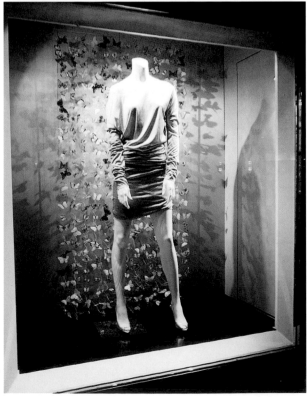

**GUCCI,** Sydney, Australia

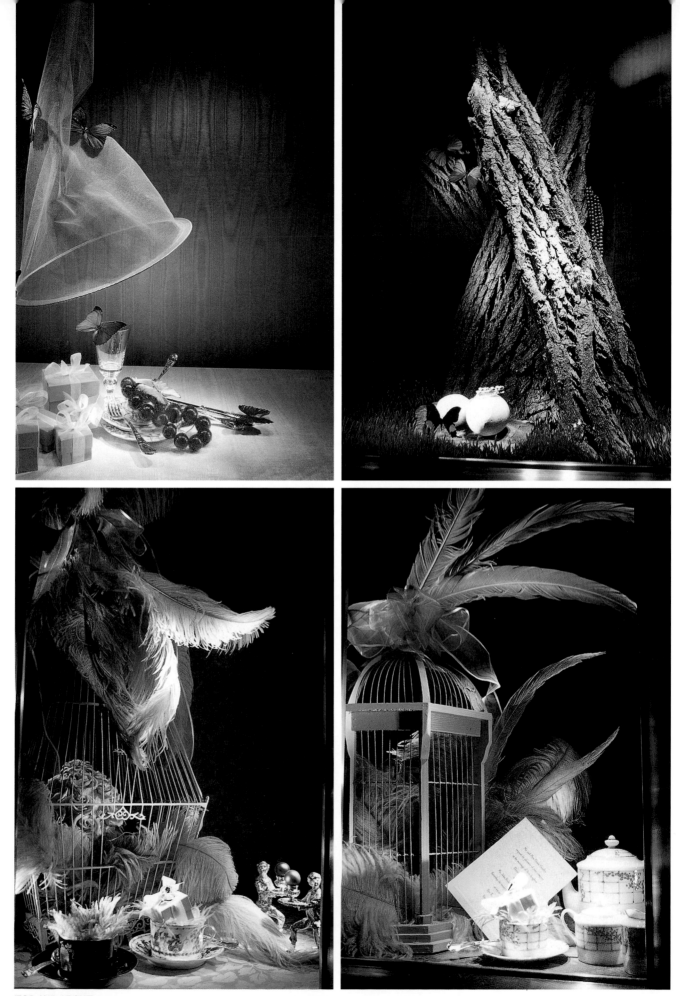

(TOP AND ABOVE)
**TIFFANY & CO.,** New York, NY

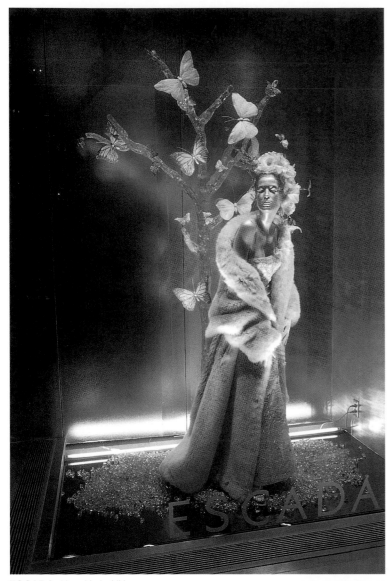

**ESCADA**, New York, NY

Escada combined lacy butterflies with an "ice" sculptured tree for this elegant setting for the pale pink gown. More "chipped ice" is scattered on the pink floor pad and the whole display is flushed with blushing pink light.

At Façonnable the bare branches burst into bloom thanks to the hundreds of pink butterflies that have come to rest on the branches. This touch of pink adds a glowing, warming note to an otherwise cool, neutral window. Note the pink touch on the bench.

In Henri Bendel's display the translucent printed butterflies flow through the window and down onto the illuminated floor platform. They are used to add color and attract attention to the two black dresses on the white stylized mannequin.

Butterflies and oversized flowers are getting intimately acquainted with Miss Jackson's realistic mannequins that are dressed in hot pink accented with a pink/yellow/ green print. Butterflies fly, flutter and rest on the mannequins in the blacked out windows.

**FAÇONNABLE**, New York, NY

**HENRI BENDEL,**
New York, NY

**MISS JACKSON,** Tulsa, OK

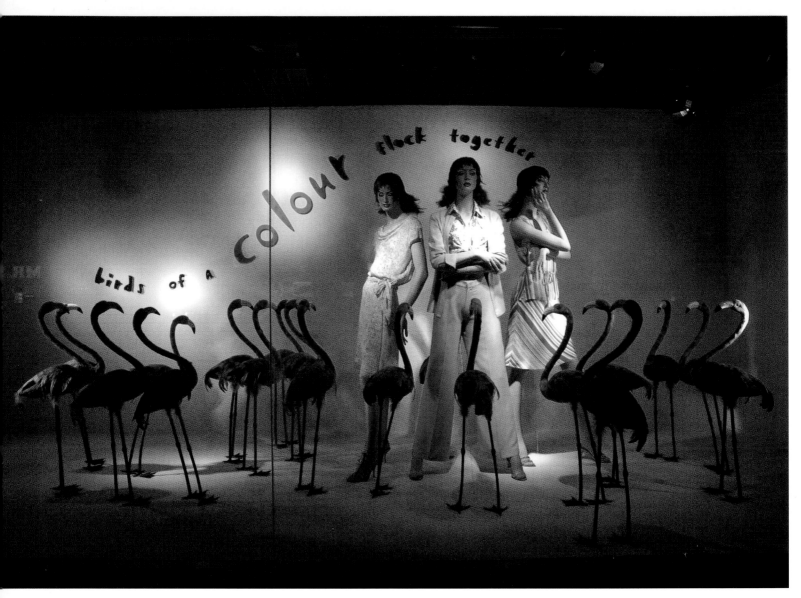

**THE BAY,** Toronto, ON, Canada
CREATIVE DIRECTOR: **Ana Fernandes**

Color Sells! The Bay, in Toronto, created these attractive windows in which each one featured a monochromatic display of casual fashions. Whether the outfits were in assorted tints or tones of blue, green red or pink—or multicolored— each display combined a flock of dyed-to-match flamingoes along with mannequins in the color coordinated outfits. Not only were the fashions, fashion accessories and the flamingoes all of a color, the mannequins wigs were also "dyed" to match. The catch phrase—"Birds of a color flock together" was used to tie the battery of windows together as well as serve as a promotional push for the new colorful casual garments.

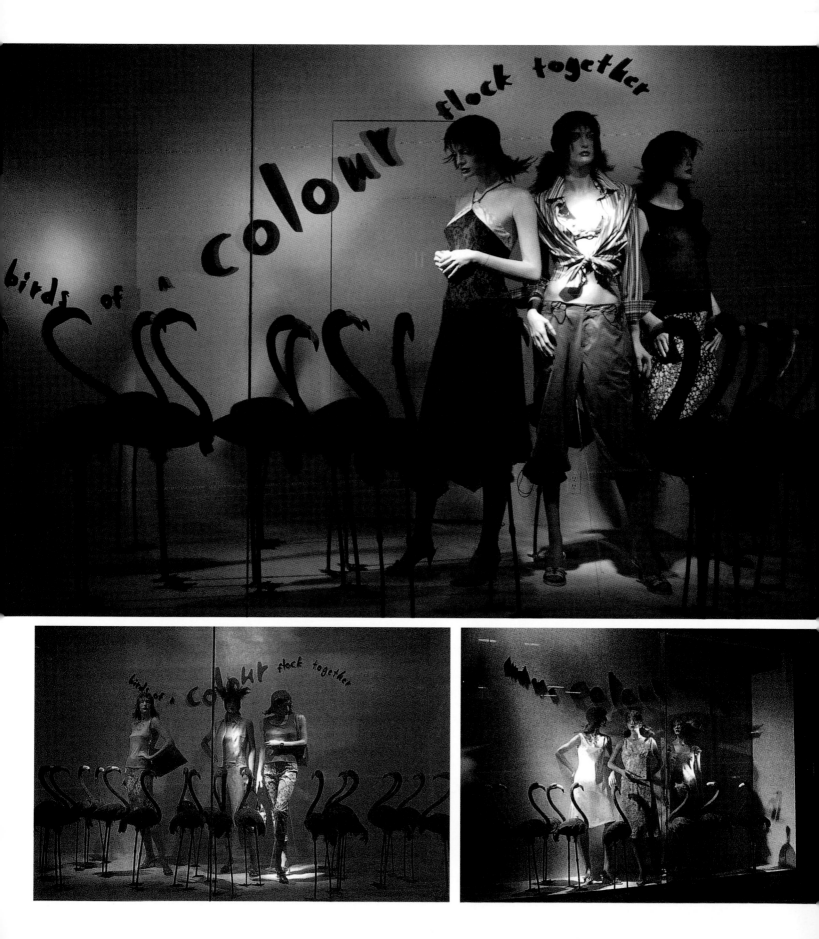

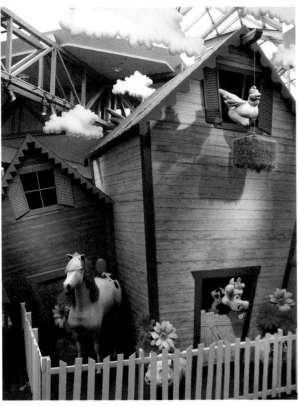

B Display of Montreal created these displays and installations that appeared around in Montreal to welcome the Easter shopping time.

For Carrefour Angrignon, this imaginative Easter farm was prepared as a centerpiece for the atrium. The aqua and purple house and barn is surrounded by a white picket fence and giant stylized flowers—almost like child's drawings—grow up from the green grass mat lawn. Assorted barnyard animals make their appearance through the windows or are standing out on the grass. Clouds float down to hover over the colorful farm set-up.

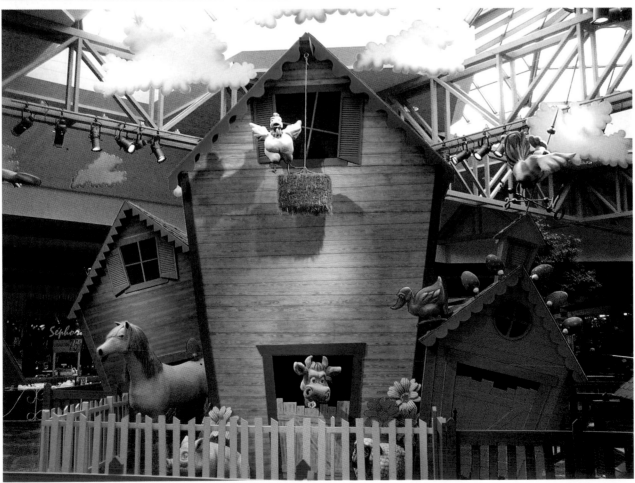

DESIGNS: **B Display,** Montreal, QC
CREATIVE DIRECTOR: **Constant Bibeau**
DESIGNERS: **Sylvie Champagne, Constant Bibeau, Eric Fleury**

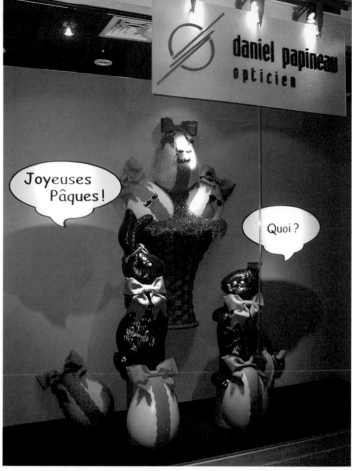

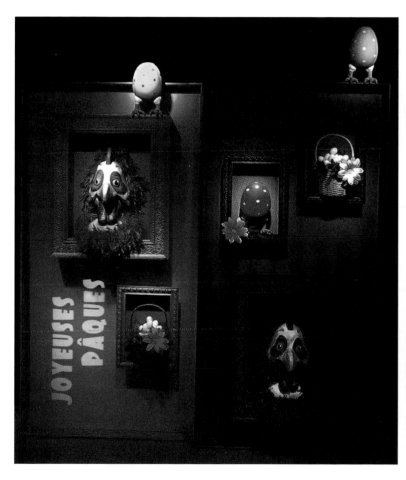

For Daniel Papineau, an optician, the over-scaled chocolate bunnies, one wearing fashionable eyeglasses, rest atop ribbon-tied Easter eggs to set the season as do the stylized chickens and eggs "framed" in the windows of the Galeries des Tours.

Most unique—and eye-catching were the can-can dancers in Lyla's hosiery windows. The dancing, hose-covered legs are kicking up their egg-trimmed skirts and seem to be upending the brooding chicken who is a real egg-laying machine.

**MISS JACKSON,** Tulsa, OK
CREATIVE DIRECTOR: **Betty Batey**
PHOTOGRAPHY: **Chaz Gaut**

They are not taking any sides in that very old debate—"Which came first—the chicken or the egg?" For Easter, the chicken and the egg arrived together at Miss Jackson in Tulsa, OK.

The pastel dresses are surrounded by hens dropping in via colorfully decorated, half eggshell balloons and while some of the papier mache chicks are holding their eggs, some have dropped them and they are making out on their own. A fun, light-hearted salute to the holiday and the soft, pastel colored garments being featured.

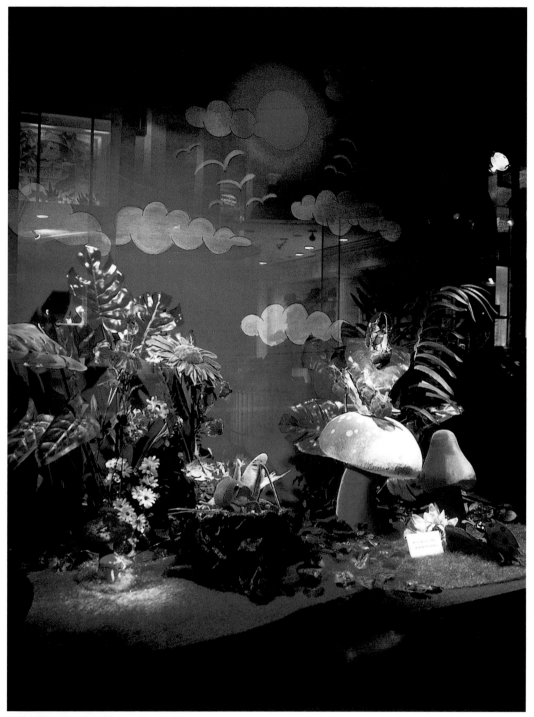

**STUART WEITZMAN,** New York, NY

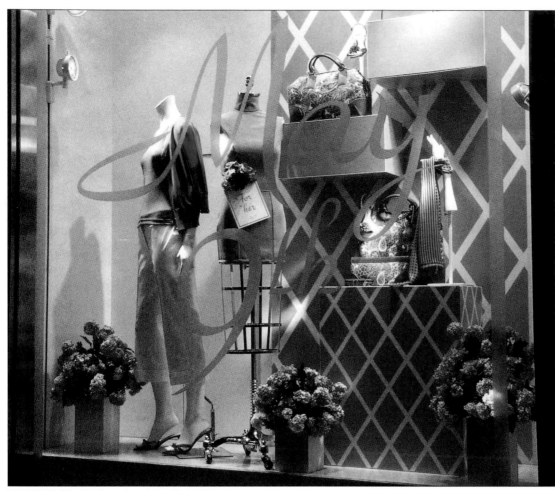

**ANN TAYLOR,** Madison Ave., New York, NY

Mother's Day is all about remembering—about loving thoughts. And what better way to remember than with flowers—and rosy pinks?

Ann Taylor made sure that anybody walking on Madison Avenue would remember the date—scripted across the front window was "May 9th." The windows was trimmed with floral tributes and a dressmaker form with a corsage pinned on it and a note "For her." The accent was on pink and the pink printed accessories in the otherwise neutral window.

A Hallmark Greetings store on Fifth Avenue turned its open-back window into "A Mother's Garden" with a pink-topped table center and an array of small gifts set out upon it. Flower boxes with live,

blooming tulips—in pink—were arranged behind the merchandise and the balance of the window was banked with branches of pussy willows.

Tiffany's floral offering was oversized roses—frankly faux and proud of it—set against a pink wall. The heart shaped box and the string of pearls said all that needed to be said.

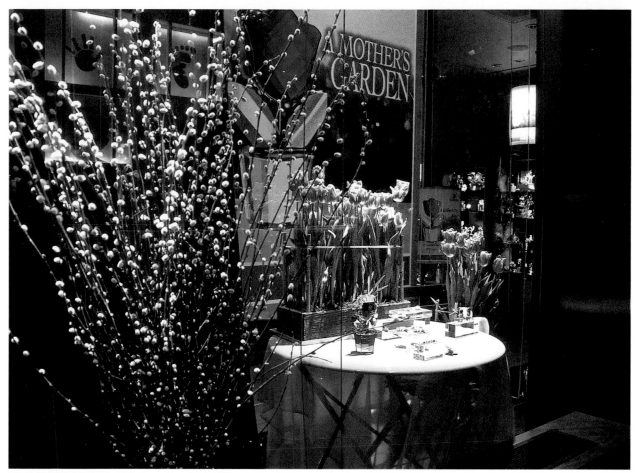

**HALLMARK CARDS,** Fifth Ave., New York, NY

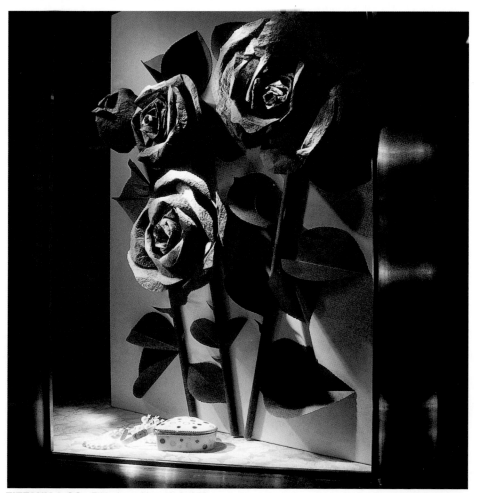

**TIFFANY & CO.,** Fifth Ave., New York, NY

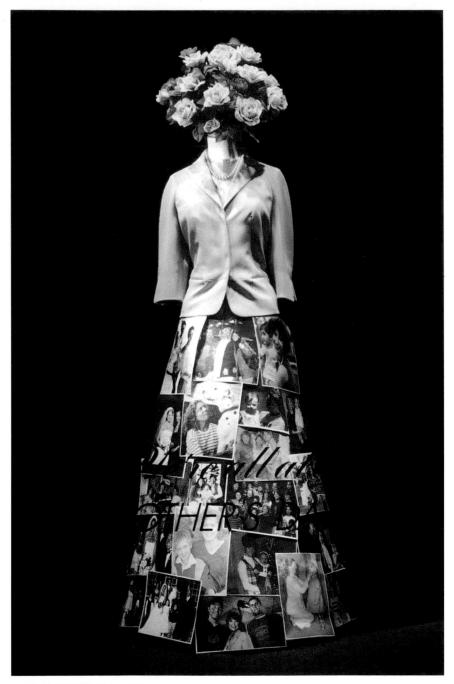

**MISS JACKSON,** Tulsa, OK
VISUAL DIRECTOR: **Betty Batey**

"My mother always said…" How well we remember Mom's words of wisdom—or the words she used to make us feel better about ourselves or the world around us. Betty Batey, the Visual Director at Miss Jackson in Tulsa, OK, created these windows to celebrate Mother's Day with Hannibal B. Johnson's book, "Momma Used To Say" in hand. The window promotion was tied in with a book signing event for Johnson and his "quoted" book.

With the addition of some flowering plants in pots on the floor and the panels of sayings on the black, back walls, Miss Jackson featured an assortment of pink toned garments. One of the window highlights was the flower-headed dressmaker form with the colorful skirt made up of photographs of the mothers of the company's employees. The title was: "We're all about moms."

The customers loved the windows and many came in to add to the long list of "mom-sayings" with memories of their own mothers' admonitions.

"...at all your peas."

"Do as I say, not as I do."

"You'd better come down off your high horse."

"If I've told you once, I've told you a thousand times."

"If someone jumps off a bridge, are you going to jump off, too?"

"Don't cross your eyes, they may stick like that."

"Call me when you get there."

"Better safe than sorry."

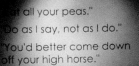

**MISS JACKSON,** Tulsa, OK
VISUAL DIRECTOR: **Betty Batey**

"Be home by ten."

"Just wait 'til your father gets home."

"Keep your elbows off the table."

"To have a friend, you've got to be a friend."

"If you're going to be snoopy, you better be sneaky."

"Mind your p's and q's."

"Chew with your mouth closed."

"Beauty is only skin deep."

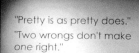

"Pretty is as pretty does."

"Two wrongs don't make one right."

"Where is your brother?"

"Don't do anything that I wouldn't do."

"Let your conscience be your guide."

"Put on clean underwear, you might get hit by a truck."

"Go ask your dad."

"When in doubt, *don't*."

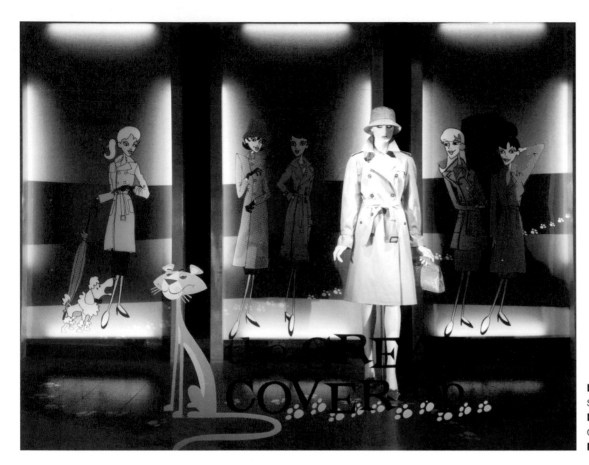

**LORD & TAYLOR,** New York, NY
SR. VP FASHION/PR/WINDOWS:
**LaVelle Olexa**
CREATIVE DIRECTOR OF VM/WINDOWS:
**Manoel Renha**

Inspector Clouseau is on the scene—following scents and paw prints of the Pink Panther into and through Lord & Taylor's Fifth Ave. windows. The search is on for the Great Cover-Up: bright, pretty colored rainwear.

Using artwork and the pastel colors so typical of the '60s, Manoel Renha and his staff created these delightful settings for the pastel-colored raincoats. The Pink Panther cavorts, glides, slides and rides through each window to tie the theme together as do the paw prints that serve as directionals for Inspector Clouseau who makes a guest appearance.

As an extra nice touch there is also a tribute to Henry Mancini—the popular music composer who wrote the very familiar Pink Panther theme. The salute said, "Lord & Taylor is proud to support the Henry Mancini Institute which continues to celebrate the legacy of a man who shared his great musical gift with the world and helped broaden the presence of music and arts education in our schools." This is once again Lord & Taylor reaching out to its customers as being part of the community.

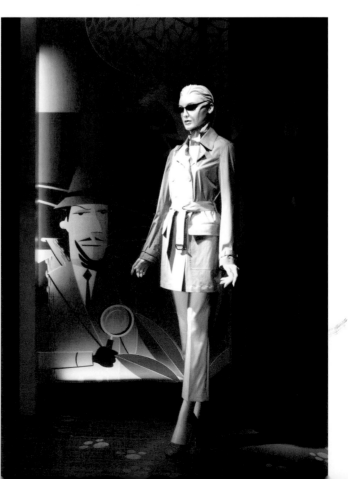

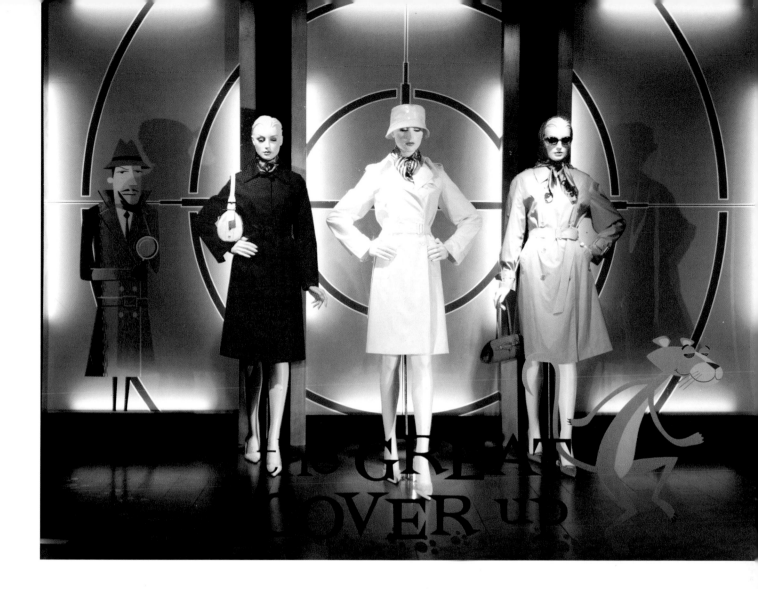

THE GREAT COVER UP

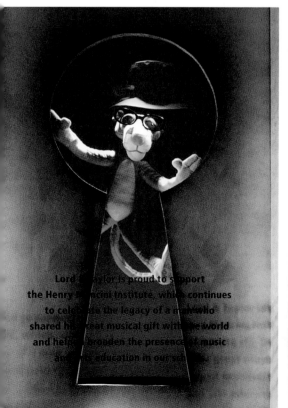

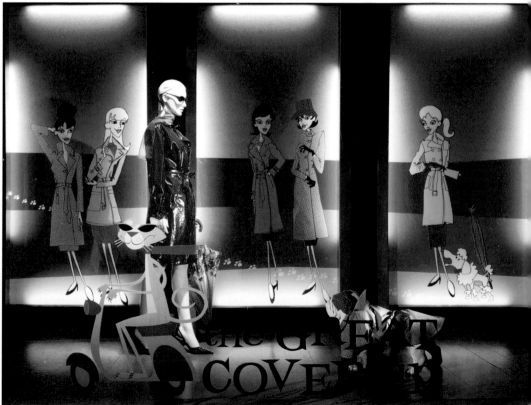

THE GREAT COVER UP

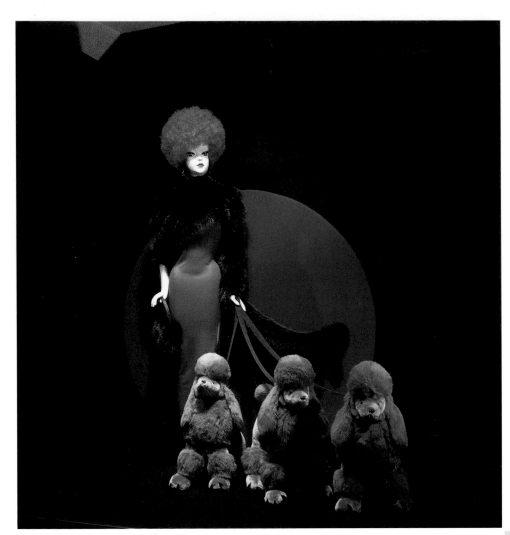

**FROHLICH FURS,** Munich, Germany

Man's best friend can also be a display's best prop. Who can resist the "doggie in the window" especially when it is cute, cuddly and pink?

Peter Rank added the blushingly pink poodles to escort the fur-wrapped mannequin in Frohlich's window. With the hot pink dress and circle behind the figure and her "hat" emulating the poodle's pouf—who could resist this shopper-stopper?

Saks has definitely "gone to the dogs" with this window filled with dog decorated pillows, poufs and papier mache dogs in assorted bright—but decidedly unreal—colors. Note how the colors in the abstract's dress are picked up by the dogs and the chairs that support the deluge of dog-gone squares.

Victoria's Secret is that Victoria loves her pink patterned pooches and is proud of it. The pooch not only appeared in the windows at the Fashion Show Mall in Las Vegas and inside the store but a "relative" was staking claim in a mall in Christiana, DE.

**VICTORIA'S SECRET,** Las Vegas, NE

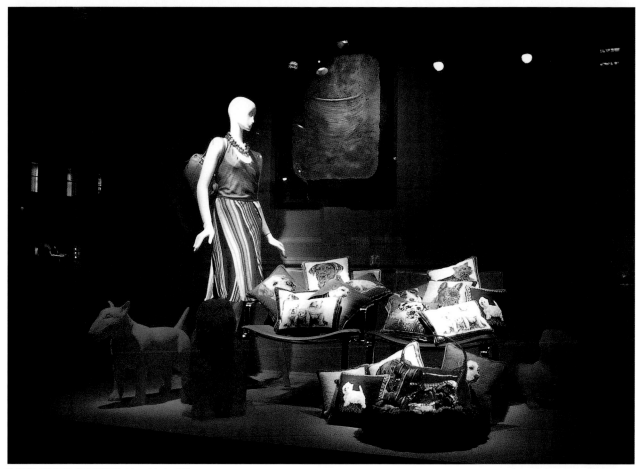

**SAKS FIFTH AVENUE,** New York, NY

**VICTORIA'S SECRET,** Las Vegas, NE

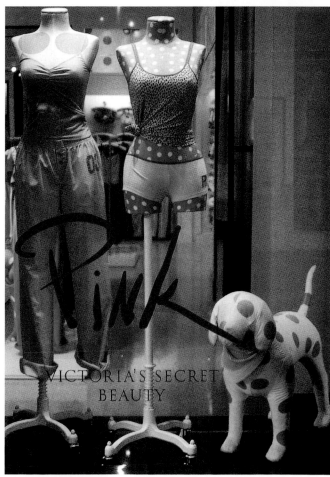

**VICTORIA'S SECRET,** Christiana Mall, Christiana, DE

43

Hermès went dog mad in its Bellagio store in Las Vegas with cut-out dogs of all colors and sizes parading amidst the multi- and brightly-colored Hermès fashion accessories. Some wore belts as dog collars, some were wrapped in signature scarves and all pointed up the message—"Colour & Imagination."

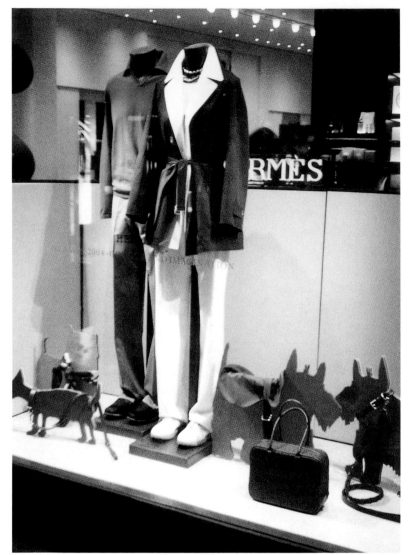

**HERMÈS,** Bellagio, Las Vegas, NE

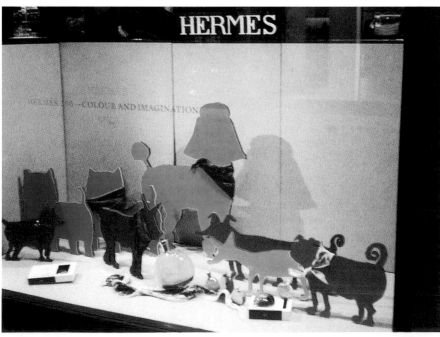

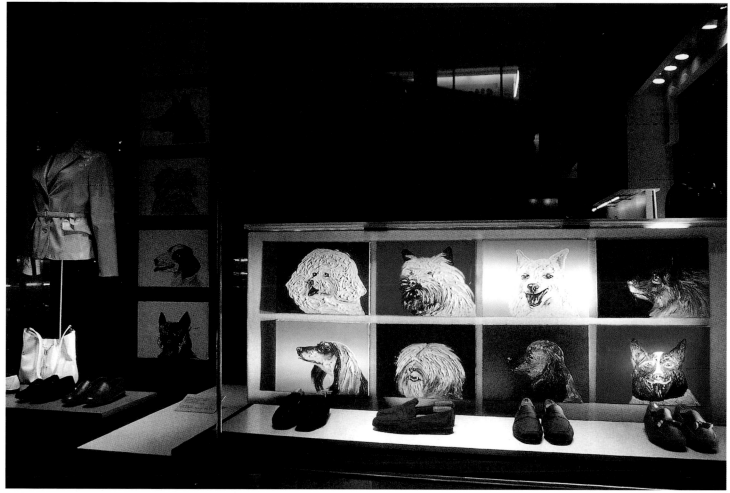

**FRATELLI ROSSETTI,** Fifth Ave., New York, NY

Fratelle Rossetti knows that shoppers will "oh!" and "ah!" over puppies and pooches, so they collected drawings of dogs to create a colorful background for the slipper-like shoes set in the foreground. We are supposed to get the message—the dog brings his master's (mistress') slippers.

In the adjoining display, the dog portraits are lined up vertically to add prestige to the garment on the dress form. The more neutral black/beige/white pictures complement the warm beige/white garment while the red shoes relate back to the window area on the right.

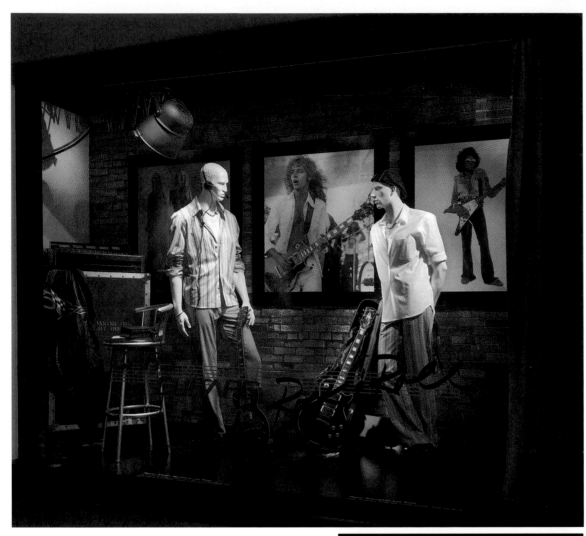

Father's Day was the date and the promotion was "Cars, Guitars and Rock 'n' Roll." The design team at Lord & Taylor's Fifth Ave store in New York City, under the Creative Director—Manoel Renha—came up with these windows that tied in the 50th anniversary edition of Chevrolet's Corvette with Gibson's Custom shop's limited edition 50th Anniversary Corvette Guitar and Father's Day gift merchandise from the L&T stock.

Not only did Corvette's newest convertible take center stage in the windows that filled Fifth Ave. with flash, splash, dash and music, but vintage autos from 1953, 1960 and 1967 were also highlighted. Guitars did not "play second fiddle" to the autos. The displays featured Lenny Kravitz's signed Flying V guitar, the 1960 Corvette Hall of Fame guitar plus Gibson's custom signature guitar models for musicians such as Duane Allman, Dickey Betts, Duane Eddy, Peter Frampton, Bob Marley and others. As shoppers wan-

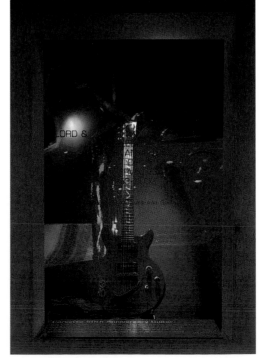

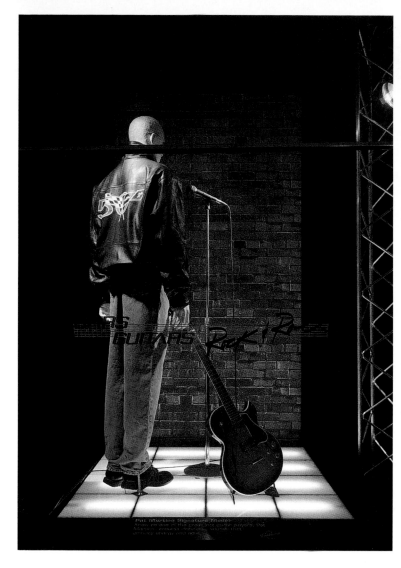

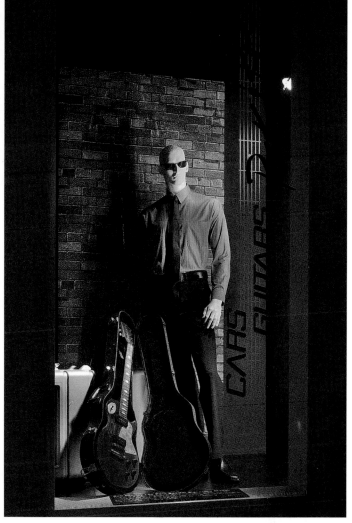

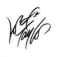

dered from window to window it was a musical journey down memory lane. Blacked out window spaces were textured with background panels of brick—some overlaid with graphics of guitar artists playing up a storm—or graphics of masses of jiving humanity—the kind that heat up to rock 'n' roll concerts. Illuminated floors or white "spotlights" on black floors added to the theatrical feeling of each presentation while copy plaques—up front—identified the instruments on view. Simple props such as microphones and sound equipment also helped fill in the rock 'n' roll imagery.

The windows that featured the classic autos showed no merchandise. The giant black and white photo-murals—scenes of rock concerts of the 1960s—carried through the "time" element as well as set the "place" for the autos on display. On the front glass the store provided the relevant provenance for these "classics." Tying in with this window presentation were several special events. There was a "block party"—a '60s thing—out on Fifth Ave and at another time people were invited to be photographed—

free—in a Corvette parked out in front of the store. Corvette outposts were established in all Lord & Taylor stores where special merchandise that tied in with this promotion was offered. Shoppers could also purchase an L&T special edition gift card for Dad that featured a 1953 Corvette and register to win special prizes. The prizes included a Flying V Gibson guitar signed by Lenny Kravitz, a weekend for two at a motor-sports experience racing school in Palm Beach Gardens, FL. as well as Corvette leather jackets and models of the 50th anniversary model of the Corvette auto.

Jim Landasek, Dir of Sales Promotion for Chevrolet said, "The partnership between Gibson Guitars, L&T and Chevrolet brings together three brands with a terrific heritage. We are thrilled to be part of this outstanding promotion." "With Gibson Guitars and Chevy Corvettes, L&T has taken window shopping on Fifth Ave over the top," is how Henry Juszkiewicz, the CEO of Gibson Guitars rated this event. Labelle Olexa, Sr. VP of Fashion Merchandising and Public Relations for L&T remarked, "Based on the success of this Father's Day promotion, we have turned up the volume and accelerated the excitement." As for the shoppers on Fifth Ave.: They had a ball!

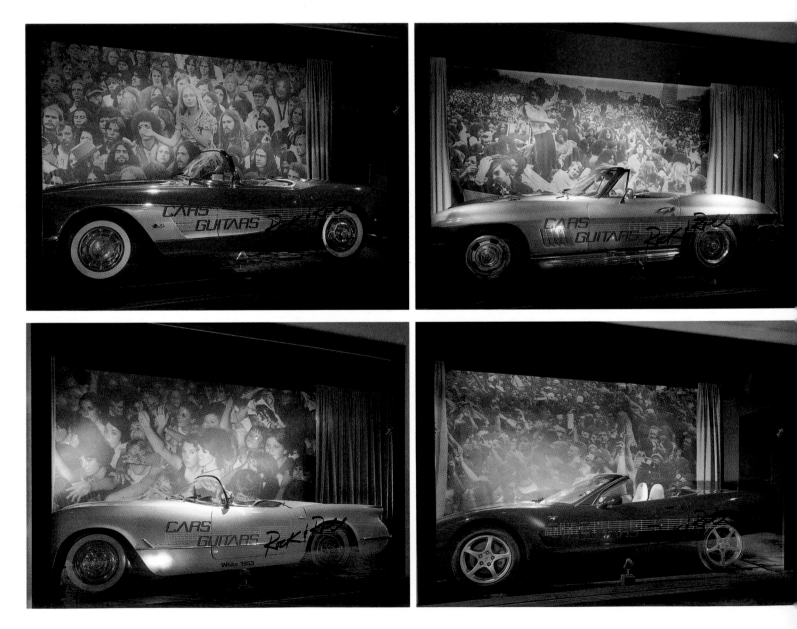

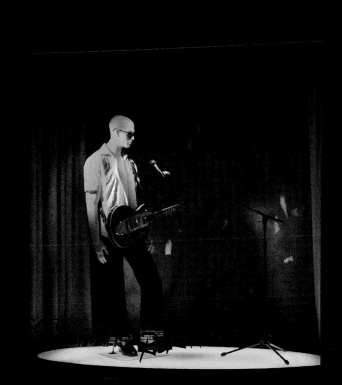

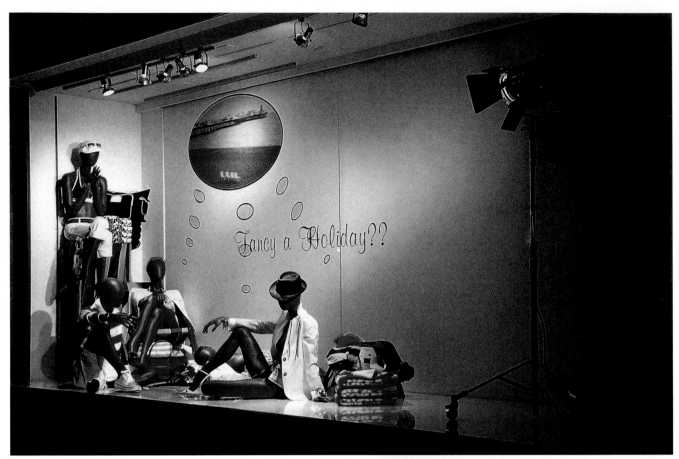

**BURBERRY,** New York, NY

Summertime is swimwear time but with cruises going all year round to all sorts of warm and exotic seaside places—swimwear is an anytime wear. On the following pages we offer a gamut of display solutions for the often "almost there" fashions.

Burberry's swimwear is really cruise/resort wear and the all-white setting is enhanced by the addition of the theatrical lights and the prevalent yellow and white color scheme. Floating overhead are "dreams" of places to visit while below, the mannequins "make do" with rooftops, sun lamps and thoughts of future holidays. Notice how cleverly the Burberry accessories have been integrated into the scenes.

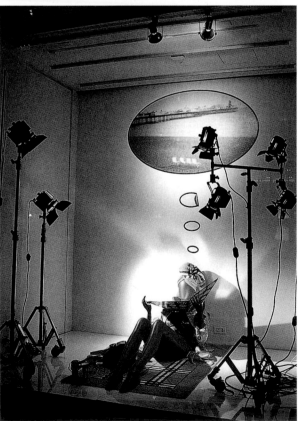

**BURBERRY,** New York, NY

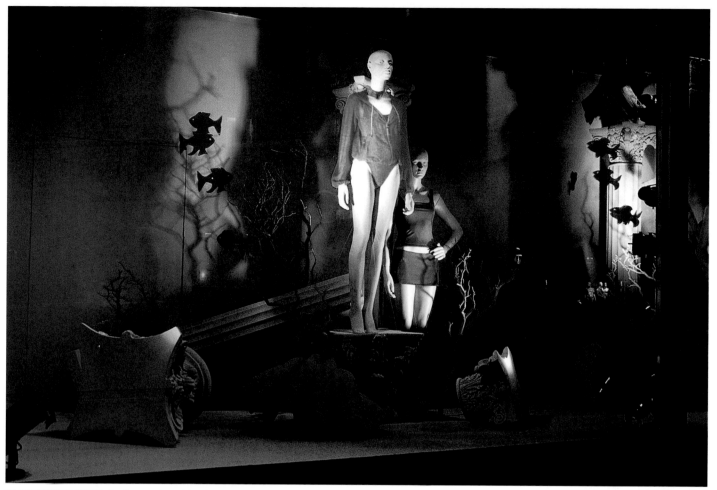

**BLOOMINGDALE'S,** Lexington Ave., New York, NY

Atlantis discovered or revisited? Bloomingdale's design team created an underwater setting for their white abstract mannequins. Surrounded by fish, coral, giant sea shells and bits and pieces of classic antiquity—the mannequins stand out in the cool blue setting. In another display that features cover-up ponchos, the colorful inflatable beach balls—on the floor and floating in space—create the desired setting for the seaside wear. The all-white ambiance is washed with a warm, golden yellow light.

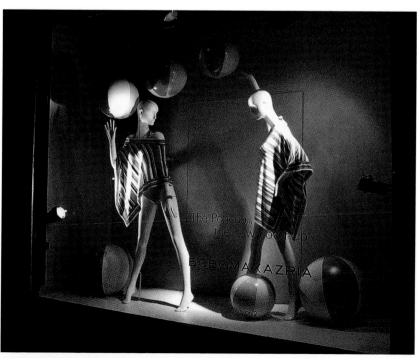

**BLOOMINGDALE'S,** Lexington Ave., New York, NY

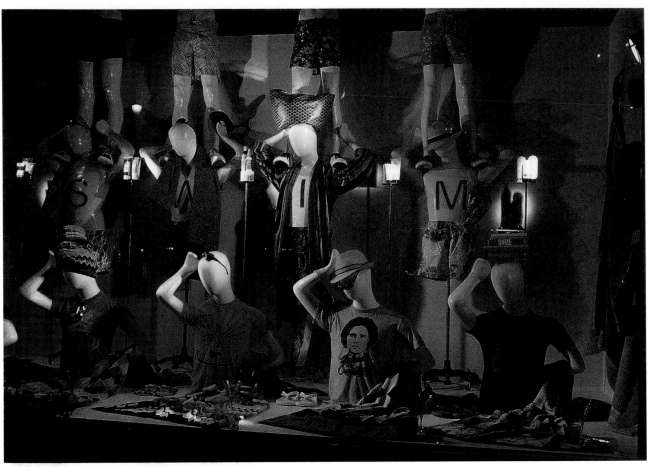

**BARNEYS NEW YORK,** Madison Ave., New York, NY

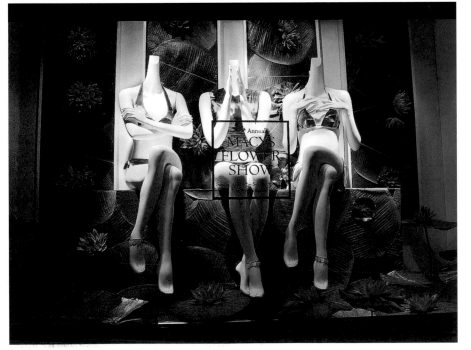

**MACY'S,** Herald Square, New York, NY

Leave it to Barneys to find a new and fun way to fill their windows with merchandise. The egg-headed torsos have their white plastic chests emblazoned with the letters that spell out S-W-I-M. These legless forms support the leggy forms on their shoulders while, on the T-shirt draped ground, the top halves of the forms are showing off more of Barneys' T-shirt collection. Neck pillows, sun visors, sun glasses, straw hats, sandals and beach towels and bags are only some of the many beach accessories crammed into the window.

Macy's headless mannequins are sitting it out on a knoll made up of lotus leaves and blossoms. These aquatic plants made the transition from flower show (which was taking place at this time) to beach wear possible.

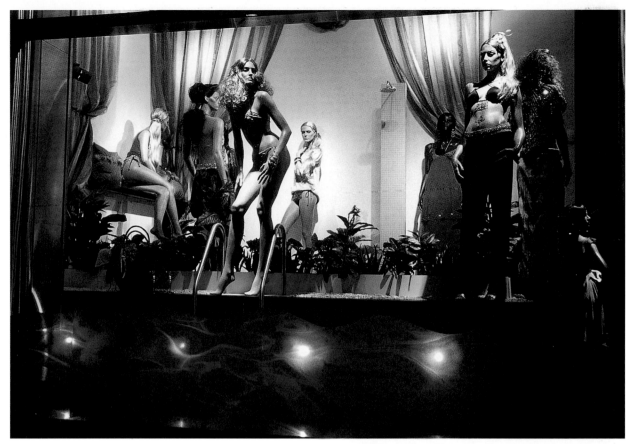

**H&M,** W. 34th St., New York, NY

At H&M the cool blue shimmering "water" in the "pool" is inviting but these sexy, realistic mannequins don't plan to get their suits wet. The tropical plants and the pull back cabana curtains help to dress the set though it is the watery illusion that really gets the viewer's attention.

The theme at Henri Bendel was Citrus Punch and the tousled haired realistic mannequins bare-ly dressed in citrus colored swimsuits lounge about in the open back window. Glass cylinders are filled with oranges and grapefruits—the pink kind—and they reinforce the citrus theme.

St. John's theatrically washy backdrop in grays, blues and pinks sets off the realistic blonde mannequin in her white suit. There is no water here and none is needed. This is fashion for fashion's sake.

**ST. JOHN,** Fifth Ave., New York, NY

**HENRI BENDEL,** Fifth Ave., New York, NY

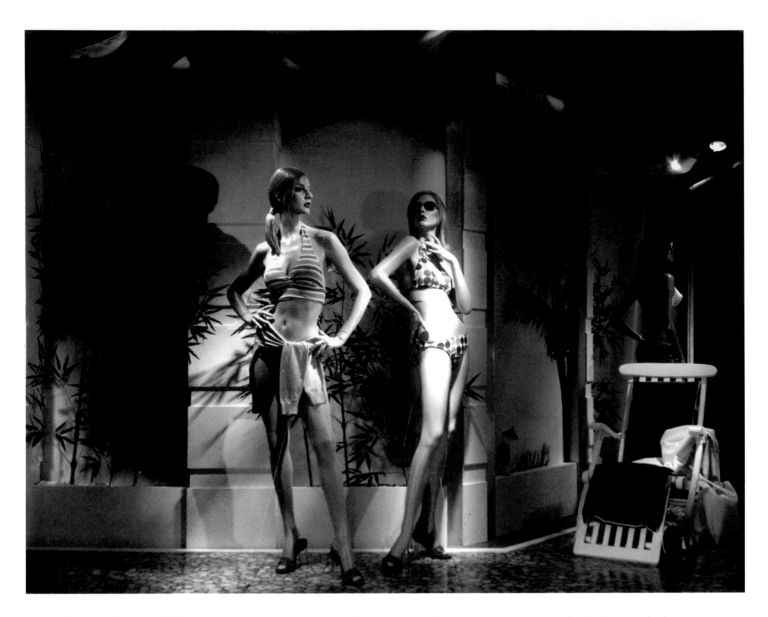

Cruise? Resort? Summer Holiday? Beachwear? Swimwear? If it has anything to do with sun and sea and warm weather Lord & Taylor had it covered with this Valentine to "the islands"—preferably "islands in the sun."

The Lord & Taylor Fifth Avenue windows glowed with sunshine and were filled with myriad suggestions for the beach or the pool. Back walls were washed with blue light to emulate clear skies and the floors were either laid with "ceramic" tiles or a printed replica of a stony beach. Interspersed were "pools of simulated

water—more printed material—and boardwalks of whitewashed planks. Tropical foliage, either in pots, planters or seemingly rising up from the ground, helped to affect the south of the border ambiance as did such simple props as roll-up (or down) matchstick blinds, beach chairs, outdoor furniture, cabana flaps and simple "architectural" shapes.

Go-with accessories such as beach bags, sun shielding hats, towels and cover-ups were naturally added to the settings to create a sense of casual realism—even to the fruit punch drink with a paper umbrella topping.

In some instances the designers relied on screened panels of palm fronds to carry through the theme.

Accessory windows and shadow box windows were coordinated with the major windows so that the story was carried through from 38th and 39th Streets on to Fifth Avenue.

There are dozens of ideas here that can be adapted to most any size window—and budget—for swimwear/casualwear presentations.

**LORD & TAYLOR**, Fifth Ave., New York, NY
SR. VP FASHION/ PR/WINDOWS: **LaVelle Oxexa**
CREATIVE DIRECTOR OF WINDOWS: **Manoel Renha**

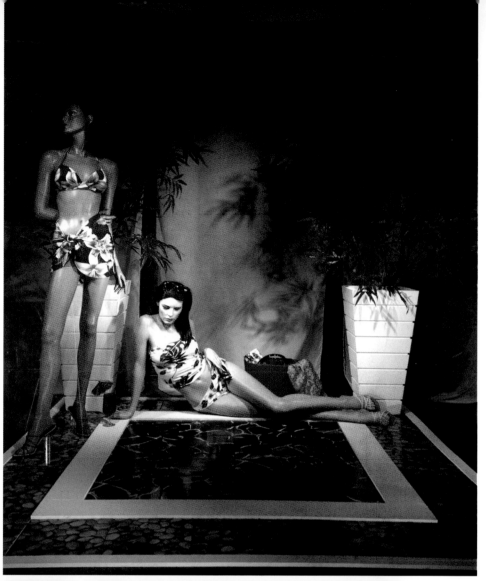

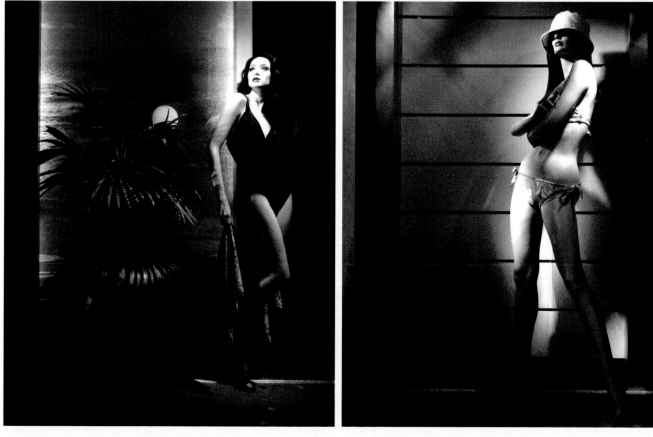

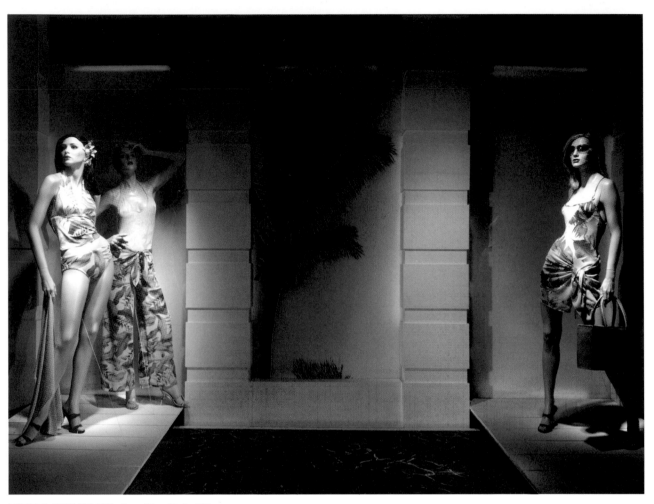

**LORD & TAYLOR**, Fifth Ave., New York, NY
SR. VP FASHION/ PR/WINDOWS: **LaVelle Oxexa**
CREATIVE DIRECTOR OF WINDOWS: **Manoel Renha**

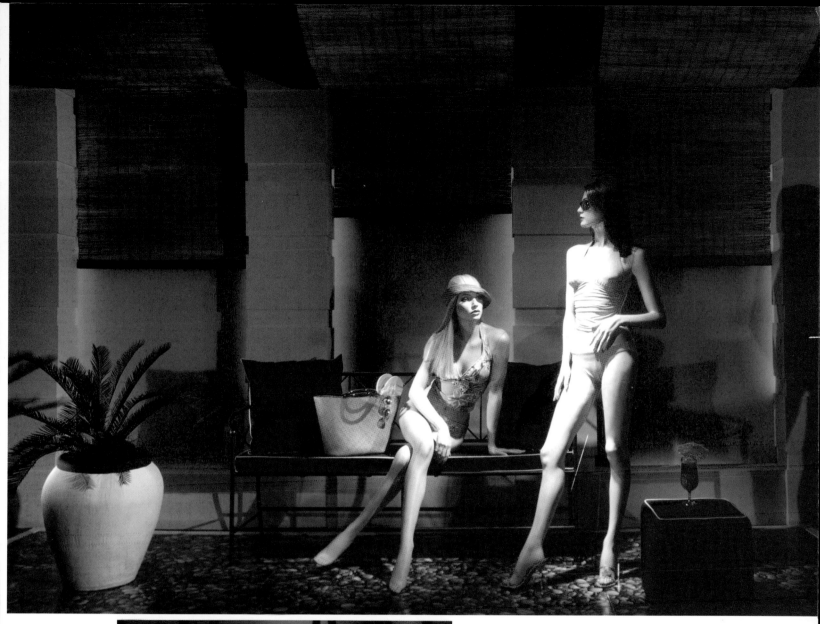

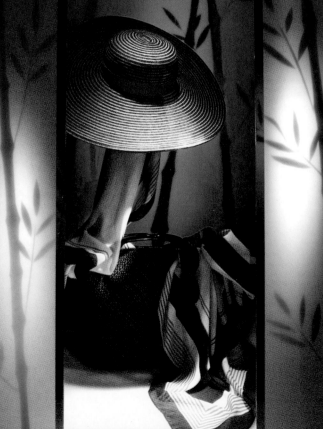

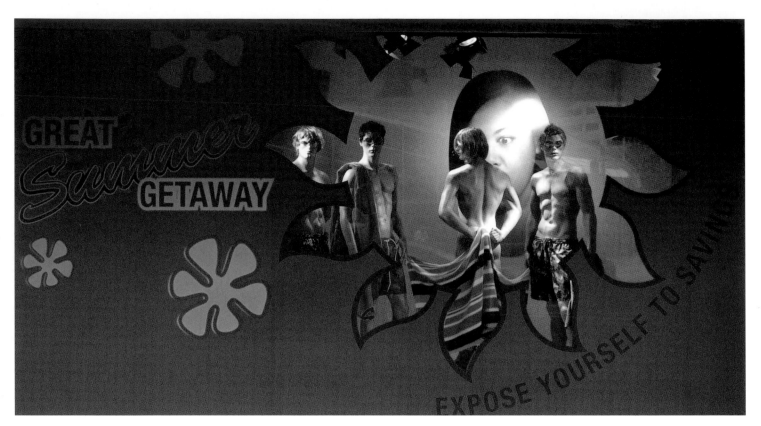

**THE BAY,** Toronto ON, Canada
DISPLAY DIRECTOR: **Ana Fernandez**

The event was twofold. It was time for the "Great Summer Getaway" and the windows were filled with colorful though scantily clad male and female mannequins in casual and beach wear. The second message was an invitation to shed inhibitions and dive right into a great sale event. Shoppers were invited to "Expose Yourself to Savings."

All the windows were masked off and the shopper's view of the merchandise was through giant voids in the shapes of flaming suns or overscaled palm fronds. The rear wall in each window carried an enlarged photo of delighted, surprised or shocked people who were getting a view of the "nudies" that the shoppers on the street were not getting. The decorously draped —from the street side—un-dressed figures were taking the Expose Yourself message seriously! All had a fun time and the merchandise came across as bright, strong and colorful.

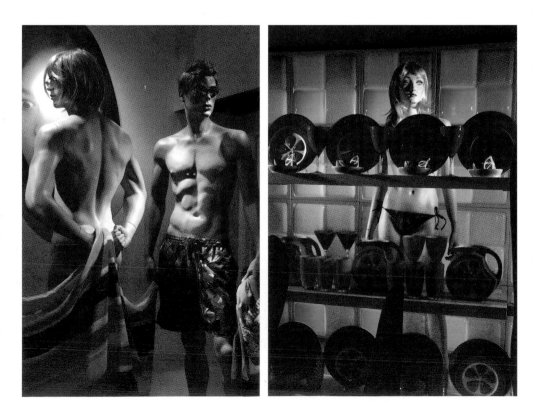

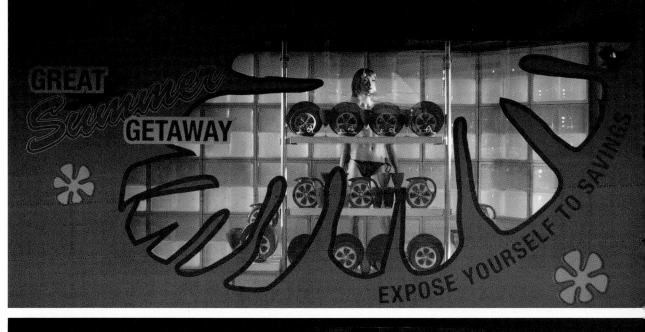

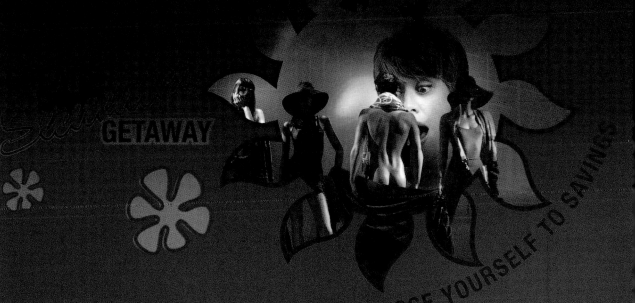

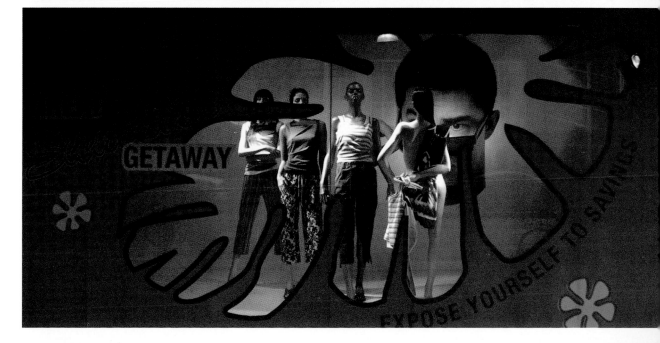

When it is cold, gray and dreary outside, it is time to think about warmer places to go and how to get to where the sun shines, the sky is blue and the water is even bluer.

A cruise ship is one way to go and to keep going. At Chanel it is the sweep of the cruise ship's prow backed up by a star studded blue sky panel that backs up the Chanel black and white suit that is sea-worthy and definitely a must for cruising.

Ghurka uses a travel poster with a cruise ship and a single plant to implant the idea of cruising and to show off their line of ready-to-travel-anywhere luggage. Travel brochures and ticket holders plus sea shells scattered on the sea blue floor certainly add to the idea.

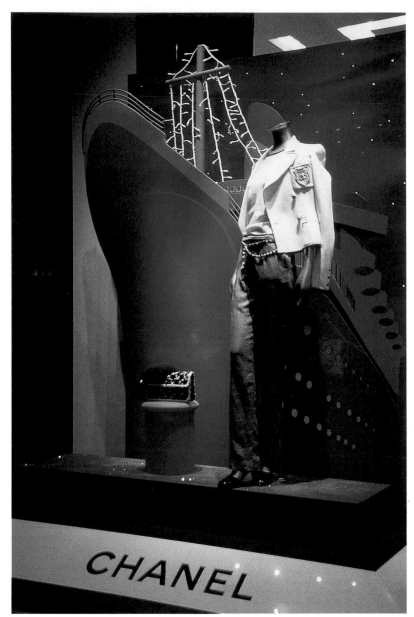

**CHANEL,** Fifth Ave., New York, NY

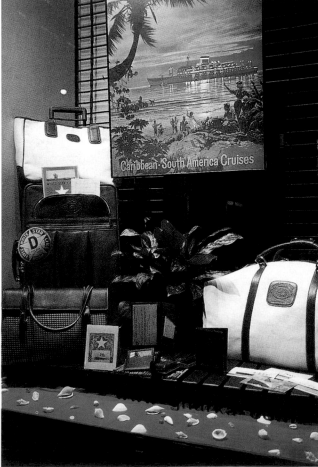

**GHURKA,** Madison Ave., New York, NY

ESCADA, E. 57th St., New York, NY

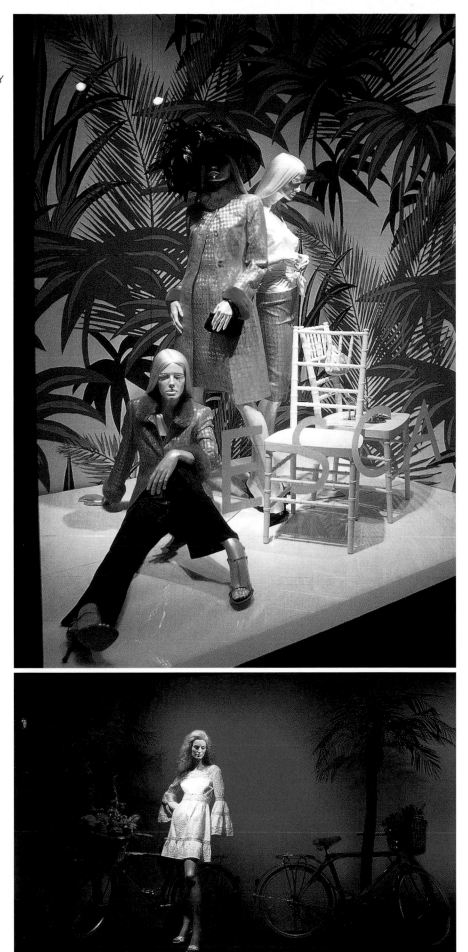

Palm trees say "resort destination." It is
what one expects to find when the cruise
ship docks at a tropical port. At Escada,
the palm foliage is printed on the walls
that completely engulf the mannequins in
a print jungle. In various shades of green
and yellow along with some crisp white
chairs—there is no doubt that the ship
has docked.

Bloomingdale's palm trees, basket of
fruit and a bicycle to get around on effec-
tively suggests a resort destination.

BLOOMINGDALE'S, Lexington Ave., New York, NY

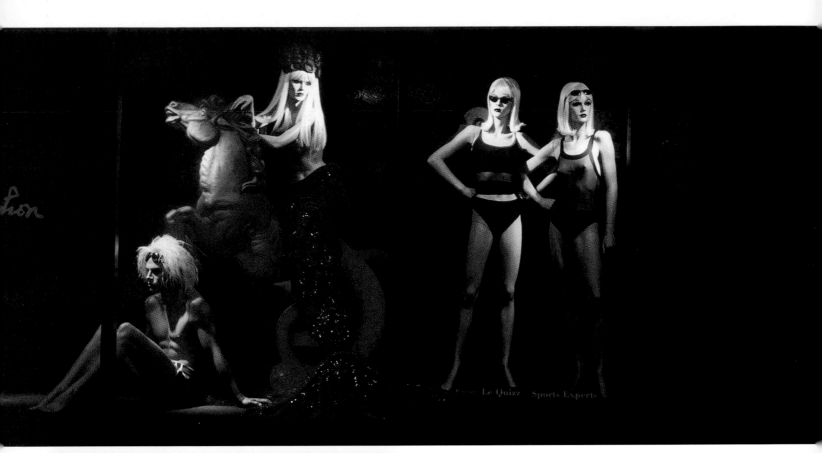

**ETALAGE B DISPLAY**

Fashion Floats—and the fish are biting! Fish, and things that live underwater, can fill a display space with the right ambiance for swimwear, cruise and resort clothes and for leisure time activities.

B Display, in Montreal, goes over-sized to make their point with these displays that feature swimwear in underwater settings filled with giant fish, shells and even a sea horse large enough to carry one of the modern day mermaids. The scale of the props in proportion to the realistic mannequins makes these windows real attention-getters.

Ferragamo's fish-filled graphic panel that is used to set the merchandise display apart from the store beyond is smart, stylish and as sophisticated in look as the merchandise it backs up. Steuben's crystal fish are the product and the display as they float in this clean, beautifully-illuminated space.

Fish floating overhead bring the viewer closer to the Teuscher Chocolatier window to get a better view of the assorted chocolates on display. The underwater setting—raised up closer to the viewer's eye level—is a fantasy—a caprice—a humourous nod to the season and the merchandise.

**STEUBEN,** New York, NY

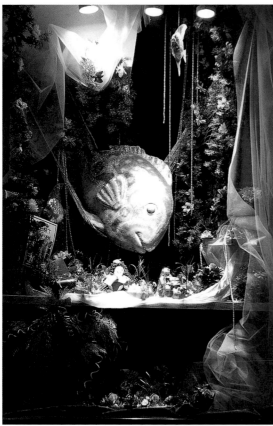

**TEUSCHER CHOCOLATIER,** New York, NY

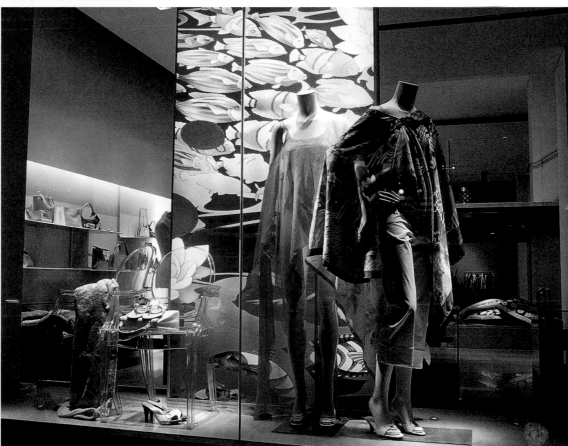

**SALVATORE FERRAGAMO,** New York, NY

Summer is the time for the sporting life. All one needs is the sportswear or casual clothes to go with the outdoor activities. Sometimes all it takes to set the scene are props such as basketballs, tennis rackets, or even hula-hoops. At other times, as in Lord & Taylor's bullseye/archery window, the giant overstatement really comes on loud and strong.

Bloomingdale's calls it an Athletic Infusion and the net stretched across the window, the shuttlecocks floating overhead and the mannequins with their rackets set off the sportish clothes.

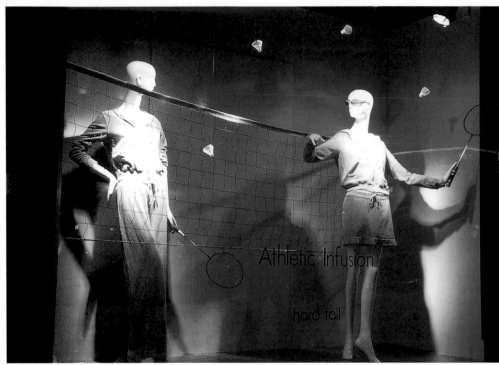

**BLOOMINGDALE'S,** Lexington Ave., New York, NY

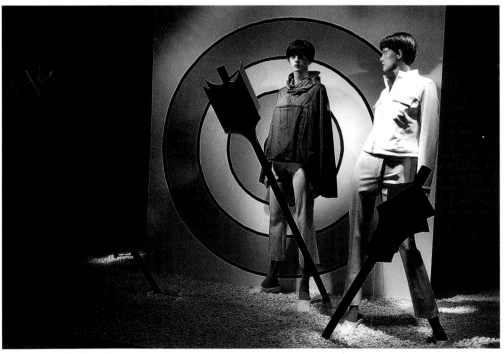

**LORD & TAYLOR,** Fifth Ave., New York, NY

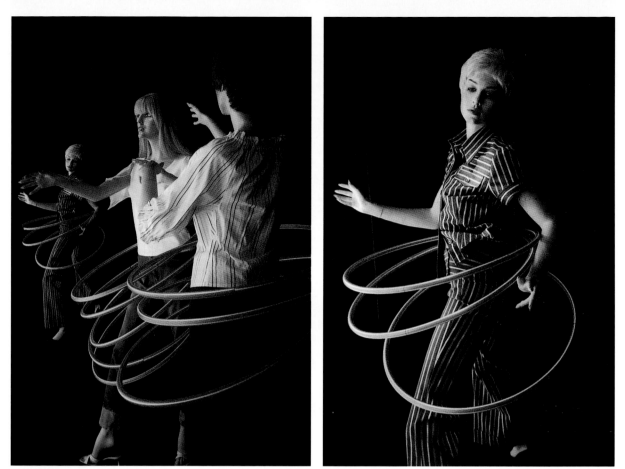

**MISS JACKSON,** Tulsa, OK
CREATIVE DIRECTOR: **Betty Batey**

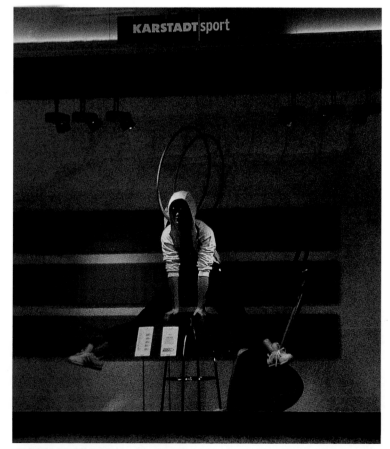

**KARSTADT SPORT,** Munich, Germany

Hula-hoops keep things in a spin at Miss Jackson and the windows are filled with "action" that is cleverly executed in an all-black space with invisible wire making it all happen.

The figure in the Karstadt Sport display is limbering up for whatever sports are on schedule. Hula-hoops—floating overhead—may be part of the practice routine.

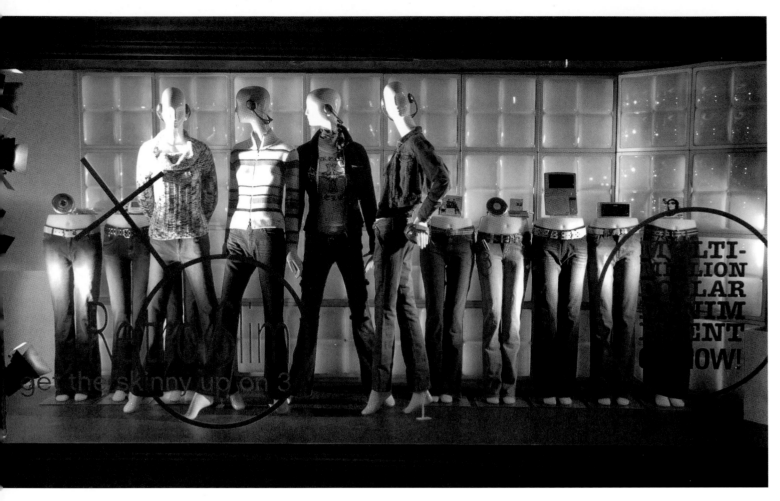

**THE BAY,** Toronto, ON, Canada
CREATIVE DESIGN MANAGER: **Ana Fernandes**

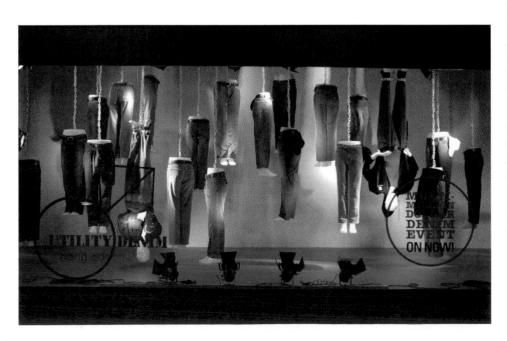

Demins are big—always big and no matter what the season or time—denims are always in. Denims and Jeans are synonymous. The Bay, in Toronto, went all out for Denims & Jeans with a Vintage Jeans promotion that included stretch denims, utility denims, retro denims and the vintage denims. Whether on the lower part of a body form or on an abstract mannequin or hung out or strung out on lines, the windows were filled with action, animation, and humor. There were figures hung upside down for a surprise element and simple props were used to set the theme for each window: Ipods and headsets for a musical accent, or telephone cords and receivers stretched across to deliver the message, or clotheslines to underscore the washability of denims. Male and female sex symbols set the record straight that Jeans are for everybody.

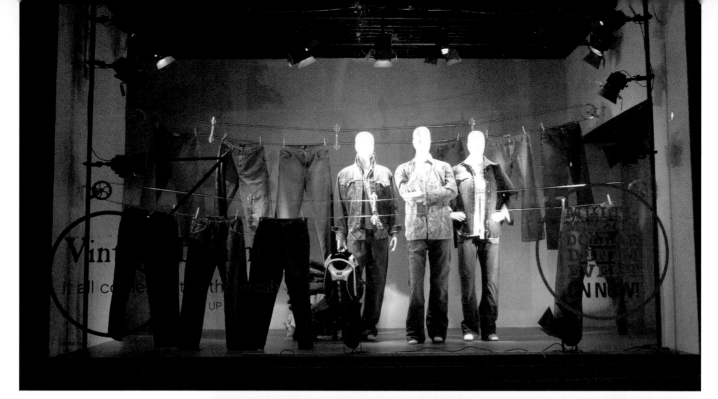

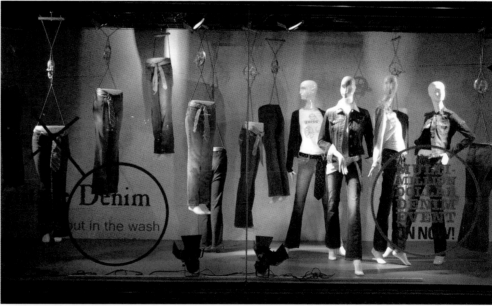

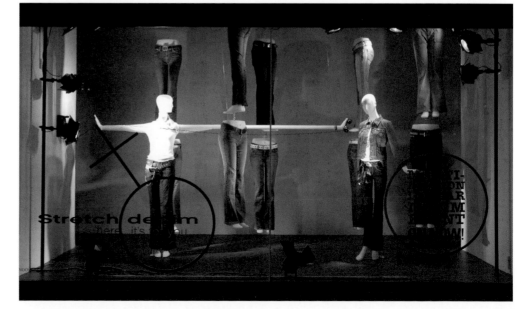

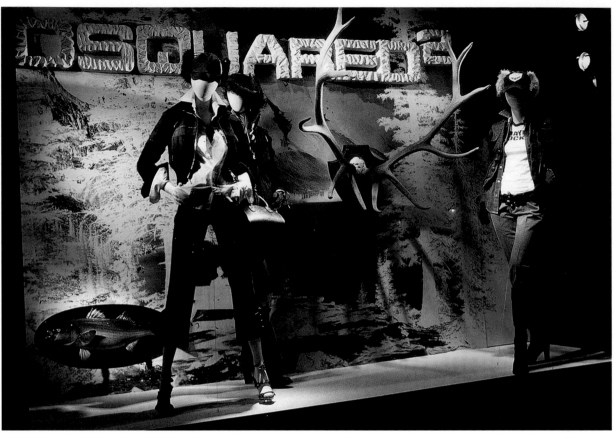

**BERGDORF GOODMAN,** Fifth Ave., New York, NY

Bergdorf Goodman got into the Denims-Jeans thing with this exciting display with a montage background of artwork and graphics in black and white accented with cerise and pink. A pair of trophy antlers and a mounted fish plaque adds some realism to this fantasy out-of-doors setting for the denims and jeans. The brand name appears in heavily textured, bark-like letters across the top of the window.

Getting ready for school means getting new jeans. Armani Exchange is ready and has their newest jeans acid washed, bleached, stone washed, sandblasted and tinted—and all displayed in giant test tubes, labeled and hung-up to dry. Note the appropriate "residue" in the bottom of each acetate test tube. The tubes are clamped and suspended from above in the open back window. A great illusion and a fun play on scale.

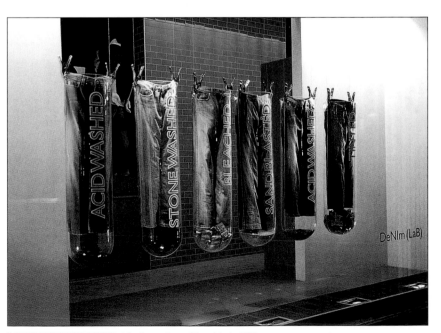

**ARMANI EXCHANGE,** Madison Ave., New York, NY

**REPLAY,** Florence, Italy

**MURPHY & ME,** Florence, Italy

At Replay, in Florence, the two level window—it goes down to a below street level—featured the company's branded jeans and jackets skewered on industrial hooks and hung from chains in the open space. The boots were lined up on the narrow ledge next to the front window.

Murphy & Me, also in Florence, also strung up their jeans. Here they are hung from a floating ship's spar and twisted with rope. The nautical graphic, on the side wall, sets the scene for the ropes and the spar. In the next window the jeans are shown on a half body with enough of the underpants showing to make a fashion statement. The nautical theme continues with the ropes, knots and the spar.

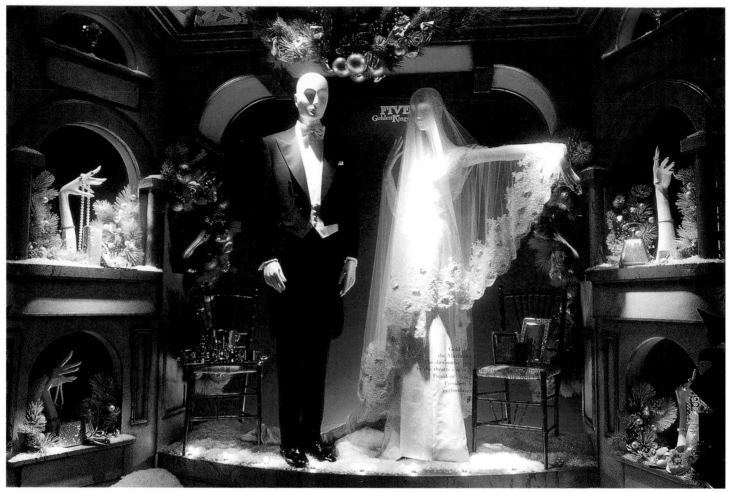

**SAKS FIFTH AVENUE,** New York, NY

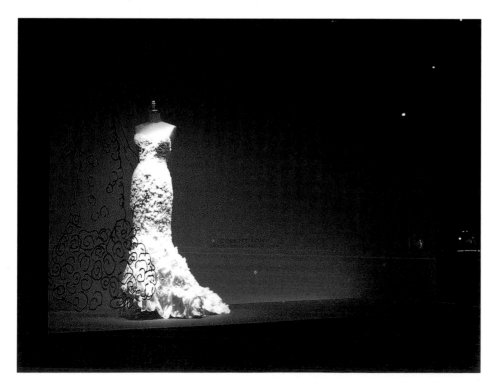

And her Bridal party!! Saks Fifth Avenue has a fine bridal department filled with designer dresses and several times a year they present some of their collection in their Fifth Avenue windows. Shown here are a variety of approaches to presenting gowns: from a display where the Bride and Groom are part of the "Five Golden Rings" from the "Twelve Days of Christmas" to a prize winning gown designed by a graduating student of the Parson's School of Design. Gowns are shown as part of a tie-in with Moet Champagne or in an abstract setting where the designers are credited on the front glass. The white on white theme is contrasted with black mesh dress forms to make a point about the gown's construction.

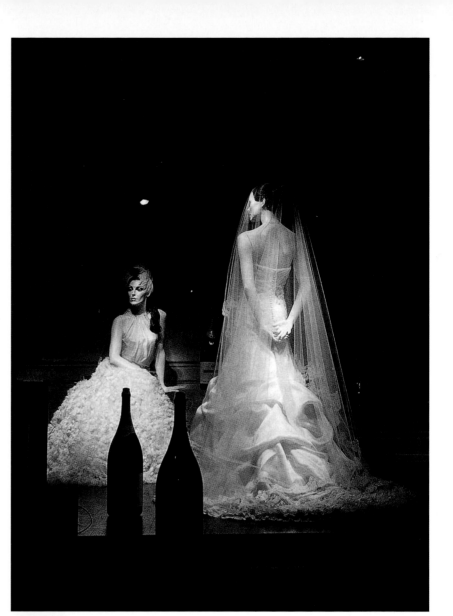

**SAKS FIFTH AVENUE,** New York, NY

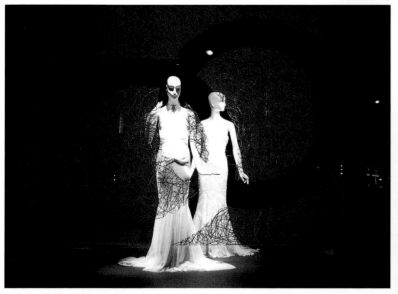

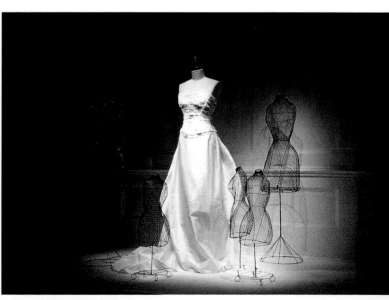

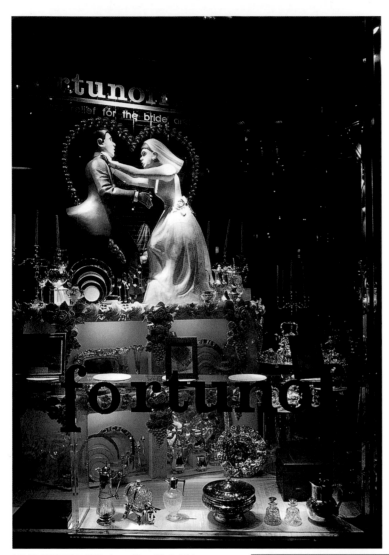

**FORTUNOFF,** Fifth Ave., New York, NY

When it comes to gifts for the bride and groom—it is retailer's choice! It can be a humorous approach like Fortunoff doing a take-off of a Norman Rockwell type of magazine cover where the couple isn't the usual "lovey-dovey" pair atop the bridal cake. Fortunoff is willing to take the stress and angst out of the gift picture by providing their Bridal Registry and some of the many "ideas" are displayed below. The solution: Register for gifts at Fortunoff.

Steuben Glass hasn't tossed rose petals down the sleek black staircase that serves as an effective tiered displayer for a variety of Steuben gifts for the bride and groom. The floral garlanding along the almost invisible stair rail sets the bridal aisle scene nicely.

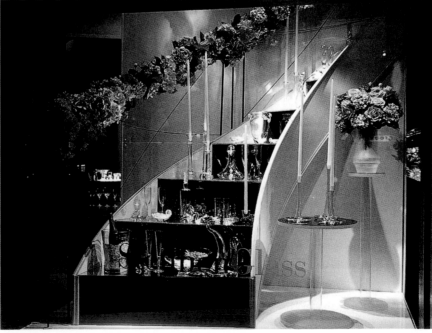

**STEUBEN GLASS,** New York, NY

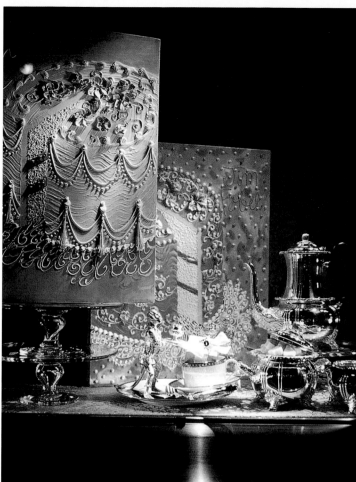

Tiffany's approach varies as well. Shown here are a pair of windows showing wedding cakes: the cake designs are "iced" on canvas and "signed": by the cake trimmer. Shown with the artwork is some of Tiffany's china and silver. In another Tiffany display a bridal veil, champagne glass and upholstered footstool serve to bring attention to the wedding rings being featured.

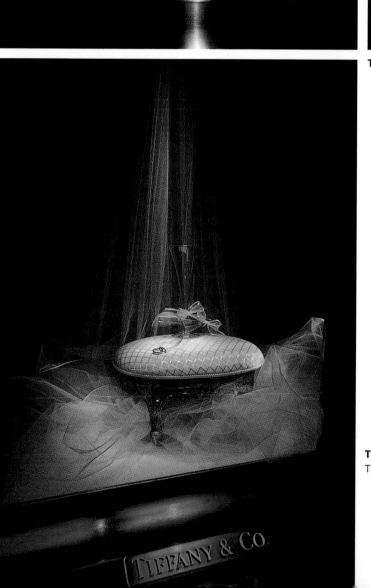

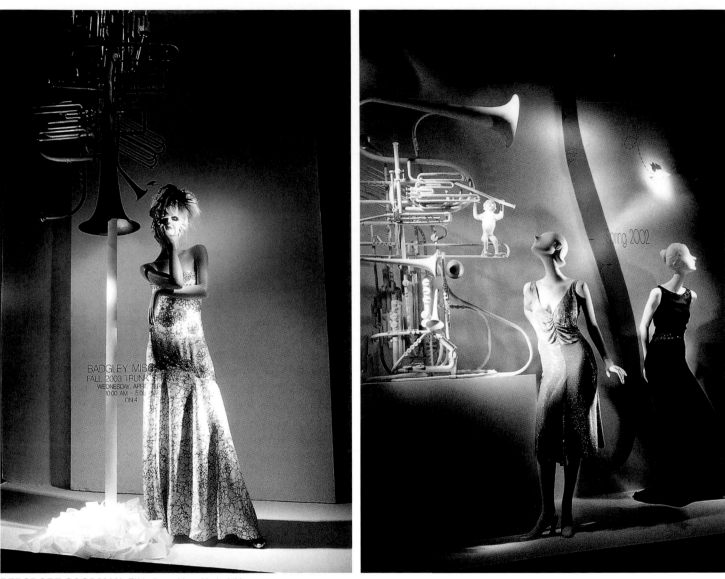

**BERGDORF GOODMAN**, Fifth Ave., New York, NY

It certainly hath charms and there is always a song in the air no matter what the season—the month—the event—the promotion. Bergdorf played a symphony in their neutral white windows with dramatically scaled collages of woodwinds and brasses.

Bloomingdale's and St., John really went all out and probably even had to remove their front windows to get the pianos in. In both displays—the grand pianos in Bloomingdale's and the spinet in St. John—the pianos fill the display space with music—a sense of refinement and elegance and serve as a foil for the black and white formal wear.

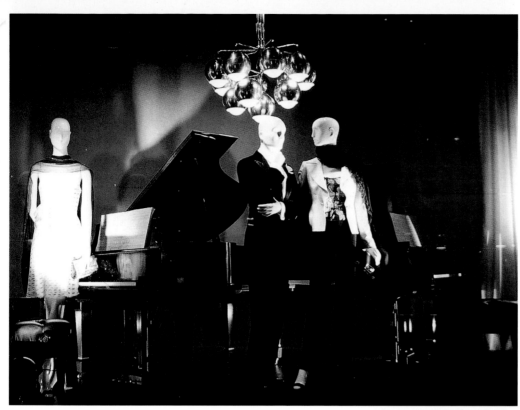

**BLOOMINGDALE'S,** Lexington Ave., New York, NY

**ST. JOHN,** Fifth Ave., New York, NY

77

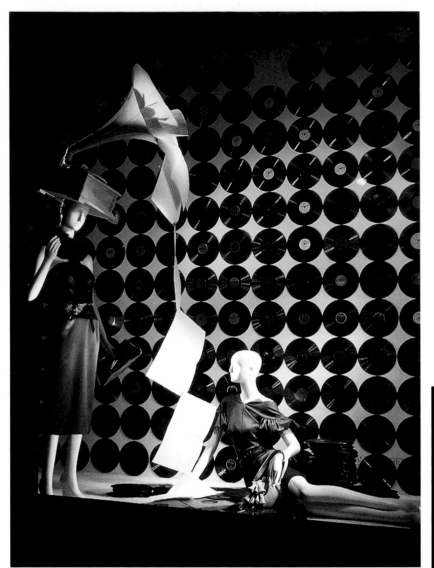

**BERGDORF GOODMAN,** Fifth Ave., New York, NY

If you can't bring the orchestra you can at least carry the tune by bringing in the records or the CDs.

Bergdorf did the nostalgia route with old, pre-CD LP records used to create a dotted pattern on the white back wall. In the foreground the mannequins are either "cutting a rug" or "jivin"—dancing up the light fantastic or wearing an old gramophone as a headdress—complete with trumpet—from which sheets of music are spewing forth. A real "solid hit"—a "top 10" display!

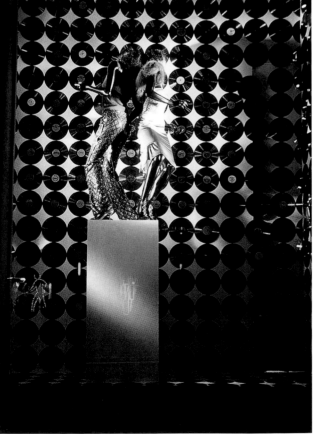

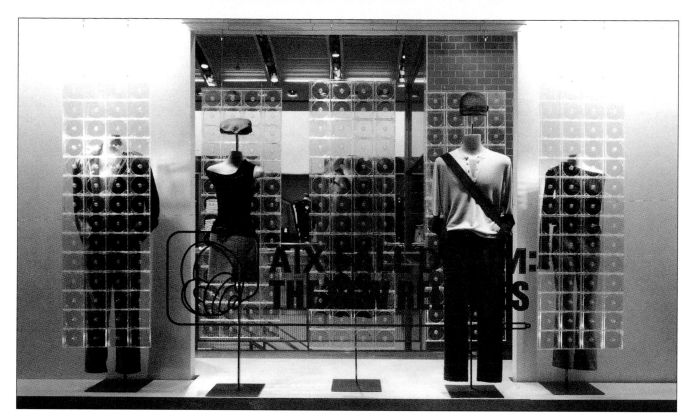

**A/X,** Madison Ave., New York, NY

CDs worked just great at A/X and their "Turn Up Your Style" promotion. Background panels were made up of the clear plastic CD cases and these were overprinted with photos of some of today's music icons. In the other window the plastic CD cases—also left empty—were also arranged into panels that were dropped either in front of or behind the dressed forms. Even without the disks you could hear the music and feel the beat. During the course of this promotion special DJs made guest appearances in the store. The copy, "New Releases" went along with the CD panels.

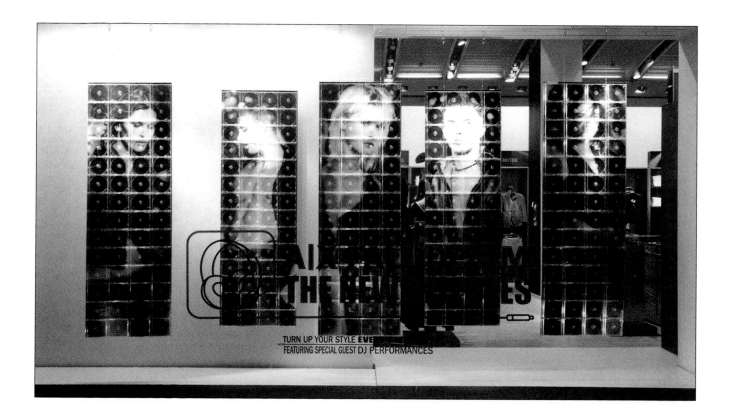

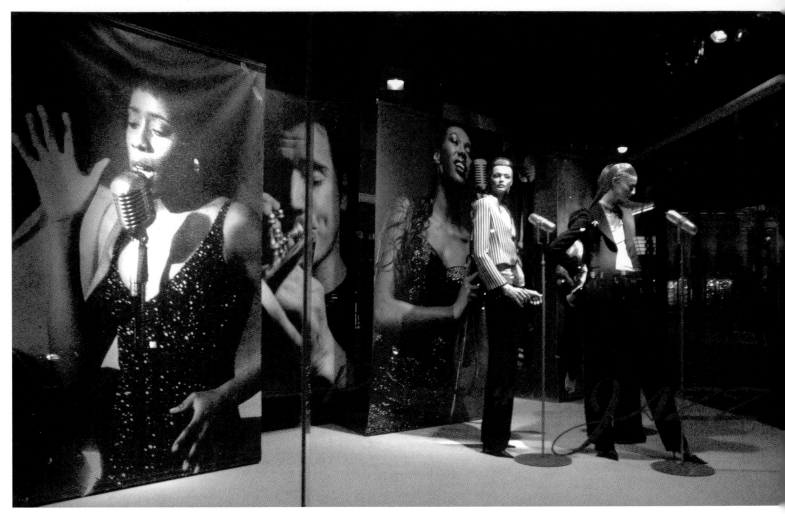

**THE BAY,** Toronto, ON, Canada
DISPLAY DIRECTOR: **Ana Fernandes**

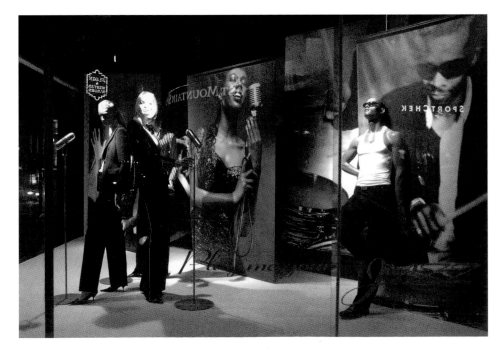

Concerts, operas, musicals—music fills the air. Whether it is heavy metal, be-bop, rap, Beethoven, Sondheim—or elevator music—music is always in fashion. The Bay, in Toronto, under the direction of Ana Fernandes, played out a black and white promotion with "Play me your Jazz." Simple props—and easy to get or improvise—include microphones and photo enlargements of Jazz greats, also in black and white like the featured garments. Add a few CDs—or record albums—guitars, etc.—and let music fill your windows.

Armani Exchange also picked up the beat— the tempo—and though we don't hear it we can see it in the sound-waves produced by the "MIX." The sharp, zig-zaggy sound-waves are reproduced on the front glass and backed up with black and white photos of the "in" crowd. Here too—some CDs would have accentuated the theme and the fashion sound would play on.

Record may be "out" and CDs "in" but music is music and at the FCUK store in Las Vegas, the background panels made up of dozens or real and pseudo album covers certainly got an "FM" message across.

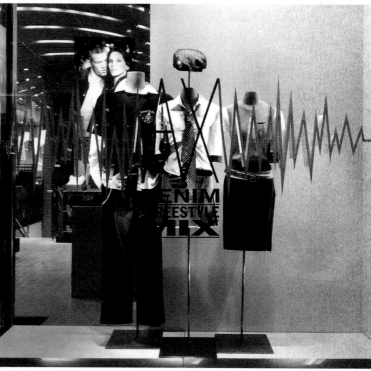

**ARMANI EXCHANGE,** Broadway, New York, NY

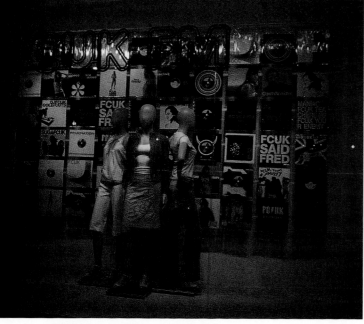

**FCUK,** The Aladdin, Las Vegas, NE

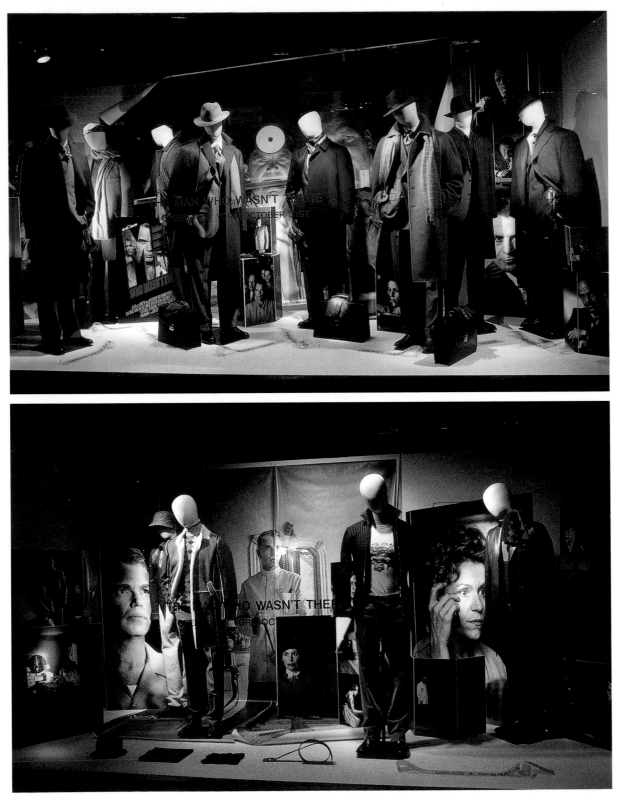

**BARNEYS NEW YORK,** Madison Ave., New York, NY

From Oscar we segue into the movies. Always a source of inspiration and always "of the moment"—what people are talking or reading about—why not tie in with one. In Fall Formals we saw what Barneys did with "Troy" and here we show how Barneys tied in with "The Man Who Wasn't There."

"The Man" may not be here but his clothes, posters, photos and other memorabilia certainly are evident in the windows. A giant black and white photo mural—blown up from a "still" from the movie—serves as the background against which assorted abstract mannequins stand out in their various couture outfits. Note the ribbon streamers on the floor in front of the mannequins that indicate which designer's clothes are being shown.

Sony, not to be outdone, took up where the movie "Spiderman" left off—in their windows. Using the recognizable face mask and glove, Sony featured some of their electronic products. Note the unique use of the TV screens for eyes in the gigantic Spiderman head and the scale of the gloved hand in relation to the PC. Sony really did "spin" the Spiderman's yarn.

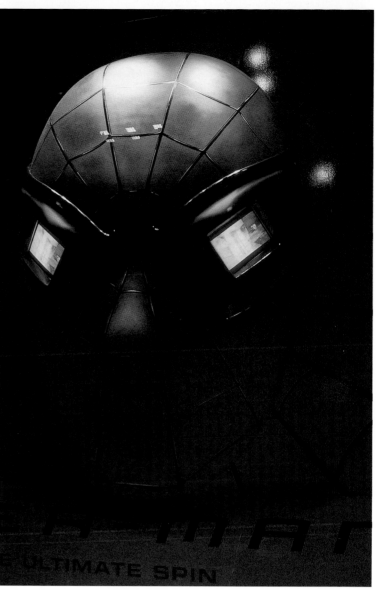

**SONY,** Madison Ave., New York, NY

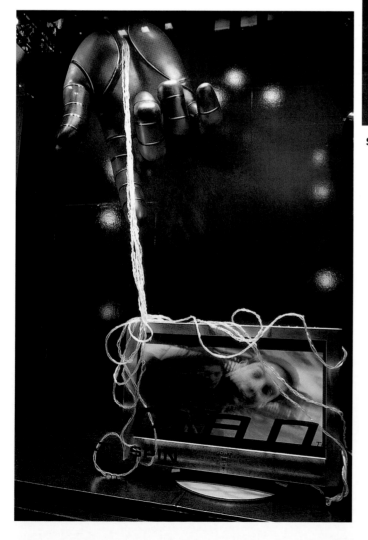

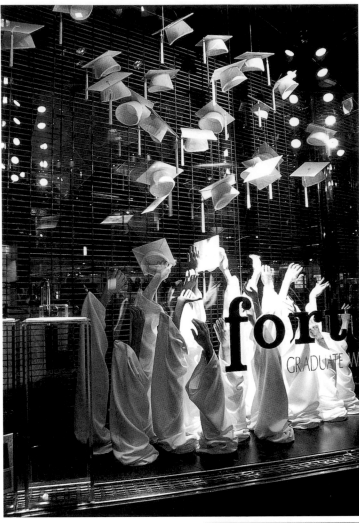

**FORTUNOFF,** Fifth Ave., New York, NY

Repetition can be annoying, or, it can be an effective way of making a point. Shown here are some "repetitive" displays where the talented display people have selected some small, insignificant and usually inexpensive object and by showing it over and over and over again, they have given that object a new stature, a new appeal and often a much more striking appearance. The "objects" can range from cans of soup to yellow light bulbs, to cotton candy, penny candy, toys and such.

Fortunoff salutes graduates with the traditional toss of the "mortarboard" hat. Numerous white sleeved arms are shown tossing their hats up into the air where they float indefinitely as they attract shoppers to come closer and check out the company's collection of graduation gifts. One hat would not have done it!

Got an idea? Usually a "light bulb" lights up when that happens—at least in cartoons. Bloomingdale's has some great new ideas for mens casual wear and in addition to the light bulbs that light up over the mannequins' heads, the floor is covered with more yellow light bulb "ideas."

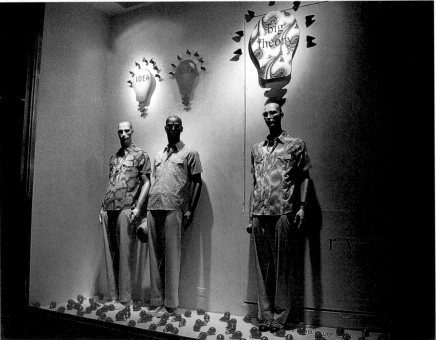

**BLOOMINGDALE'S,** Lexington Ave., New York, NY

Gucci robbed the candy store and cleaned out the carnival of all of its paper twists filled with pink cotton candy to create these high calorie, sugar enriched displays. But they are SWEET!! The vertical bins of gum-drops and jelly beans make the shopper ask—"how did they do that??"—while the swirls of cotton candy can rot your teeth even with the window between you.

Andy Warhol and Campbell's Tomato Soup, in its signature red and white can, say "RED" better than anything else and since Bergdorf's men are sporting bright red, this display certainly does bring shoppers over to get the humor ands sophistication of the setting and the product.

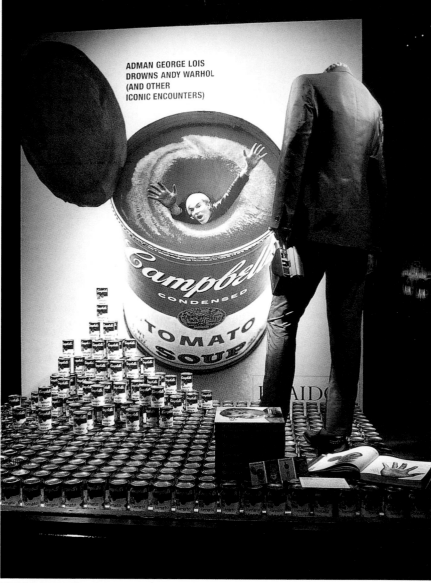

**BERGDORF MEN,** Fifth Ave., New York, NY

**GUCCI,** Fifth Ave., New York, NY

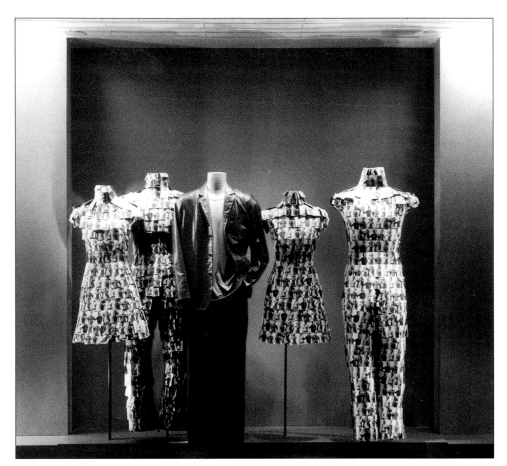

**A/X,** Madison Ave., New York, NY

Armani Exchange made a real big deal out of small black and white photos from the penny arcade. Here they are used to dress the dress forms that back up or accompany the A/X dressed dress forms. It was all about "Being Me."

Saks used heads to turn heads in this heads-up presentation in their corner window. A special nod goes to the black wig draped over one of the wig heads that broke ranks from the dozens of other Styrofoam heads lined up on the walls. It broke the "monotony" that could have settled in and caused just enough of a break to get the shopper to respond.

Small yellow Japanese toys clutter the floor at Moda in Lima as designer Karina Barhumi has fun with Mother's Day. The headless forms are loaded down with more of these lightweight creatures to create an impact full display—that isn't traditional.

Sevigne, in Munich, under the design direction of Peter Rank, lined up toys, hearts and flowers—in regimental tiers—to create a unique background for the firm's jewelry. There is no language barrier with repetition. It sounds the same and gets the same results no matter how you say it.

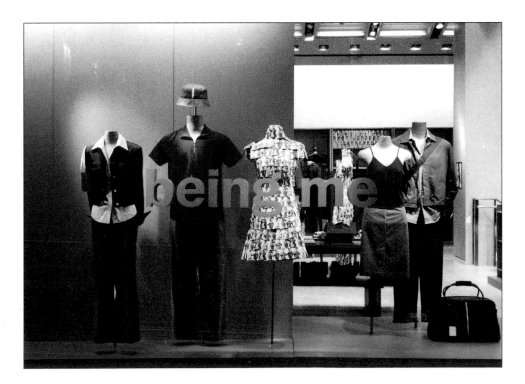

**SEVIGNE,** Munich, Germany

**MODA,** Lima, Peru

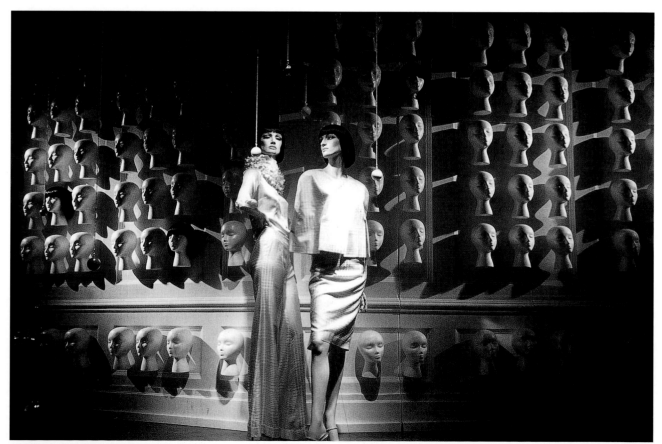

**SAKS FIFTH AVENUE,** New York, NY

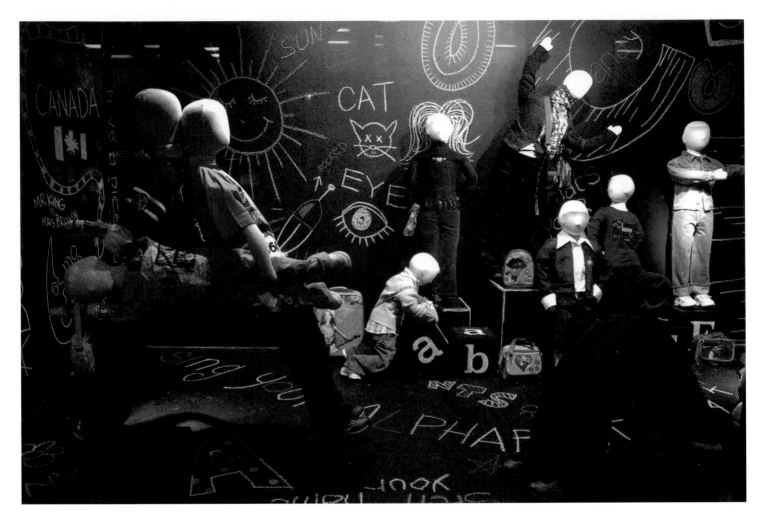

The Bay in Toronto went all out with its back-to-school promotional displays that featured "blackboard" backgrounds graffitied over with colored chalk drawings done by sophisticated "kids." The doodles, drawings and comments spread out from the back wall down onto the equally black floor and even to the front glass where "back@it" was accented along with "reeding, riting and rithmetic" as subtitles.

Blank faced, white abstract mannequins literally and figuratively filled the windows with action and excitement. Black cubes, chalk outlined, served as risers to add a sense of animation to the arrangement— but—more than anything—it was the chalk graffiti that made the big impression on passersby. Even the "teacher" writing on the blackboard was "tagged." Great Fun!! Great effect!! Pleasing for parents and children.

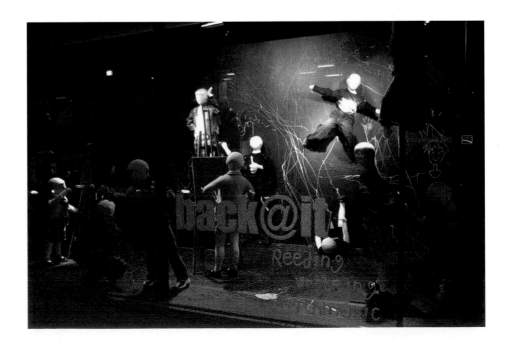

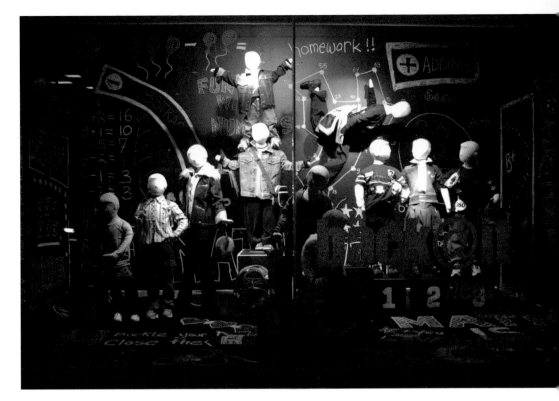

**THE BAY,** Toronto ON, Canada
CREATIVE DESIGN MANAGER: **Ana Fernandez**

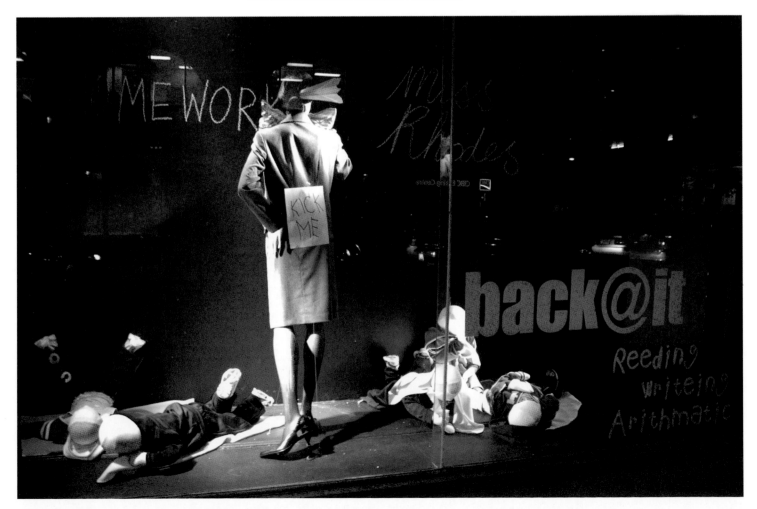

Etalage B Display, a Montreal-based display house, prepared these windows for the Place Dupuis Mall in Montreal. Highlighted were some of the "advanced studies" and the mannequins were dressed to suit the "subject matter." Each window featured garments and/or accessories provided by the various tenants in the shopping center and they were "credited" on the front glass. Collages or montages, on the rear walls of the windows, defined the "subject matter" with appropriate symbols or decorative motives that further helped to explain the outfits on the mannequins.

Also shown here is the window prepared for the optical shop, Farha. Graffitis is the name of the design and it shows the student or teacher surrounded by books—and on the blackboard are some of the designer brand names of the eyeglass frames carried in the shop.

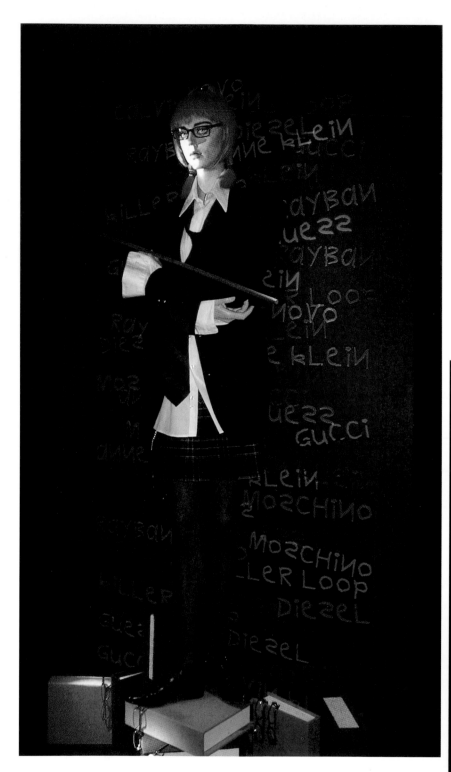

**PLACE DUPUIS,** Montreal, QC
**FARHA,** Montreal, QC
DESIGN FIRM: **Etalage B Display,** Montreal, QC
CREATIVE DIRECTOR: **Constant Bibeau**
DESIGNER OF GRAFFITIS: **Catherine Begin**

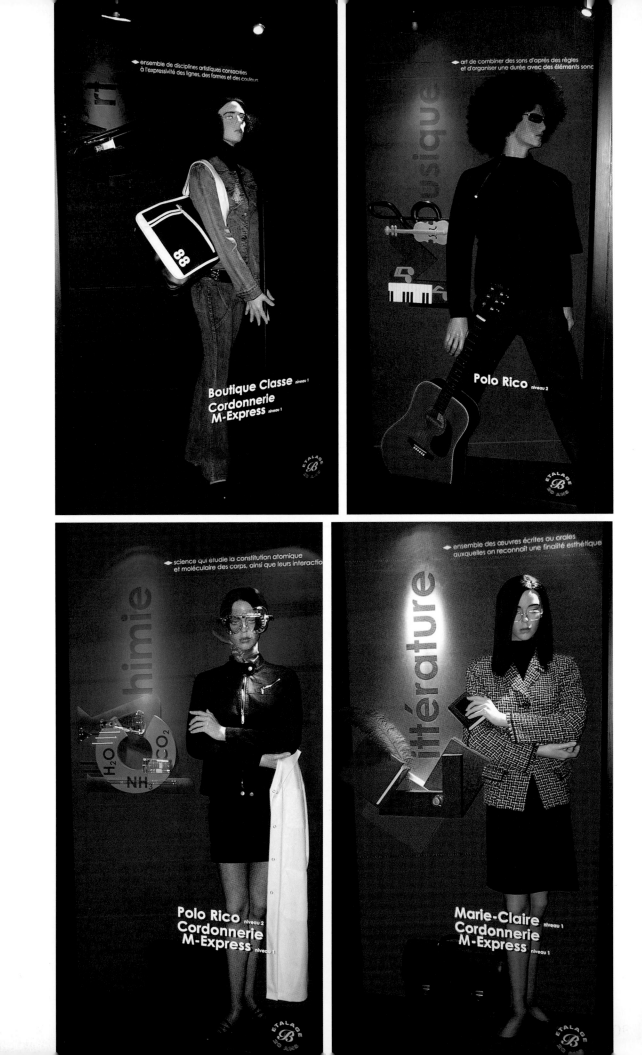

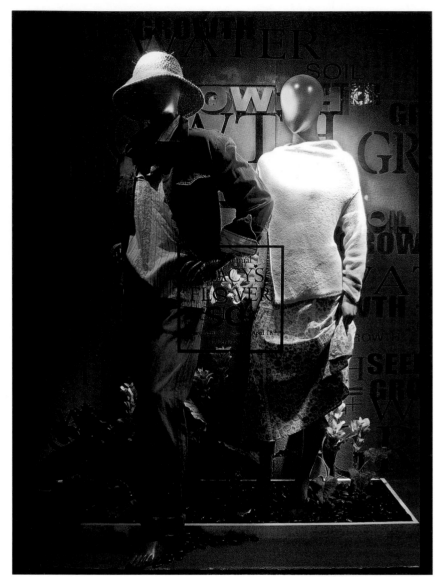

**MACY'S,** Herald Square, New York, NY

Some of the words say something and some of them are their to puzzle the viewer. Words ask to be read—and the reading is the gimmick that brings the viewer up to the window. The letters—the fonts—the colors and weights of the individual letters all say something about the meaning of the word—or words.

Macy's is growing up for the season and the background panel is filled with key words that tie in with the gardening theme going on up front. The abstract mannequins are "growing" along with the flowers in the "garden" in the window.

Bergdorf brings shoppers closer to read the "rules" as pronounced by *Esquire* magazine on what's in and what's not for menswear. Some are quite amusing and all are worth reading twice. A very effective window display simply created with blow up copy on foamcore.

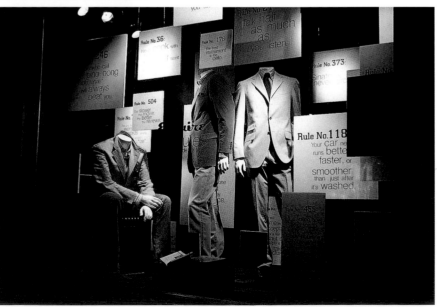

**BERGDORF MEN'S SHOP,**
Fifth Ave., New York, NY

Not to be outdone in "lettering" their messages—the design team at Barneys has used everyday, inexpensive "things" in a new and fun way. Here the key words are used to attract the viewer and they are "written" out with small plastic cups applied perpendicular to the back wall to create a three dimensional effect.

Everyday signs—the signs that we see whenever we move about—take on new meaning and serve to attract when they appear where they usually are not. DKNY is about to take shoppers on a "road trip" with garments made for the person-on-the-go—and how better to set the scene than with road signs that you don't have to read—because you recognize them—but not in display windows.

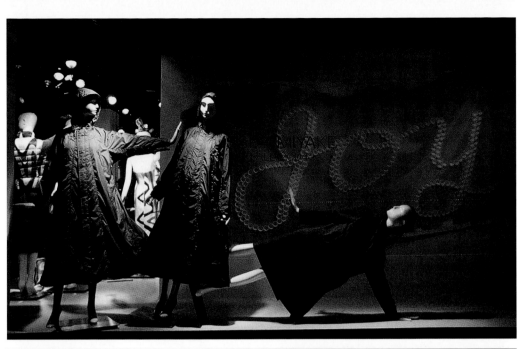

**BARNEYS NEW YORK,**
Madison Ave., New York, NY

**DKNY,** Madison Ave., New York, NY

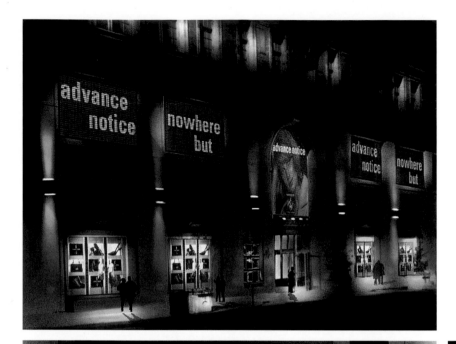

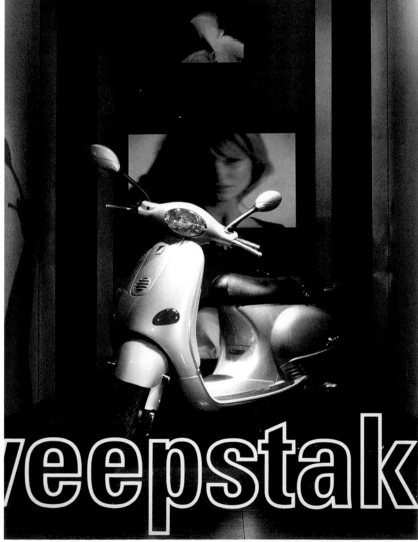

## sweepstakes

You could enter to win great prizes
from Wednesday, July 14th through Sunday, August 1st

Grand Prize: a sleek, stylish silver Vespa® ET2 Motor Scooter

First Prize: Panasonic 42" 16:9 Plasma television

Second Prize: A shopping spree at Lord & Taylor to get you
started on your new fall wardrobe

No purchase necessary, see ballot in store for details.

**LORD & TAYLOR**, Fifth Ave., New York, NY
SR. VP FASHION MERCHANDISING & PR: **Lavelle Olexa**
DIV. VP OF VISUAL MERCHANDISING FASHION & SPECIAL
EVENTS: **Manoel Renha**

# advance notice trench

"This is the first time we have promoted a pre-fall event in our Fifth Avenue windows and we are very excited to support an aggressive effort on the part of our merchants to secure early fall looks nowhere but at Lord & Taylor." Thus spoke Jane Elfers, President and CEO of Lord & Taylor in announcing the "Advance Notice" set of promotional windows that broke forth with a preview of what was ahead—and in the new fall catalog.

That "notice" made quite an impact on Fifth Avenue especially as night fell and the illuminated signs covering the second story windows —over the main display windows— lit up and announced "Advance Notice" and "Nowhere But." The store became a block long, high tech billboard and the archway over the main entrance to the store featured a mega blow-up of supermodel Serena Arnold whose face also graced the cover of Lord & Taylor's fall catalog. It was that catalog whose fashions were now being revealed in actuality in the display windows and in the videos playing out in the windows.

The windows featured a selection of looks from the "pre-season trend book." Black metallic stylized mannequins wore some of these newest of the new fashions while surrounding them—on myriad plasma screens— there were behind the scenes clips of the photo shoot that produced the images in the catalog. These high concept videos were produced by Orasis—the prestigious Greek company that produced ads and events for the 2004 Olympics in Athens. Lavelle Olexa, Lord & Taylor's senior VP of Fashion Merchandising & Public Relations traveled to Athens to edit the videos that were actually shot in New York.

In addition to the Advance Notice displays and to make it even more of an event, L&T ran a sweepstake with a sleek and stylish Silver Vespa Motor Scooter as a grand prize, and for First and Second places there was a 42" 16:9 Panasonic Plasma TV and a shopping spree for a new fall wardrobe in the store.

What a great idea for any pre-season promotion: play up the upcoming catalogue! Using mannequins and mixed media—show off the new garments along with blow-ups of pages of the catalog. Lord & Taylor's "Advance Notice" showed how it could be done.

advance notice
animal

houndstooth

**LORD & TAYLOR**, Fifth Ave., New York, NY
SR. VP FASHION MERCHANDISING & PR: **Lavelle Olexa**
DIV. VP OF VISUAL MERCHANDISING FASHION & SPECIAL EVENTS: **Manoel Renha**

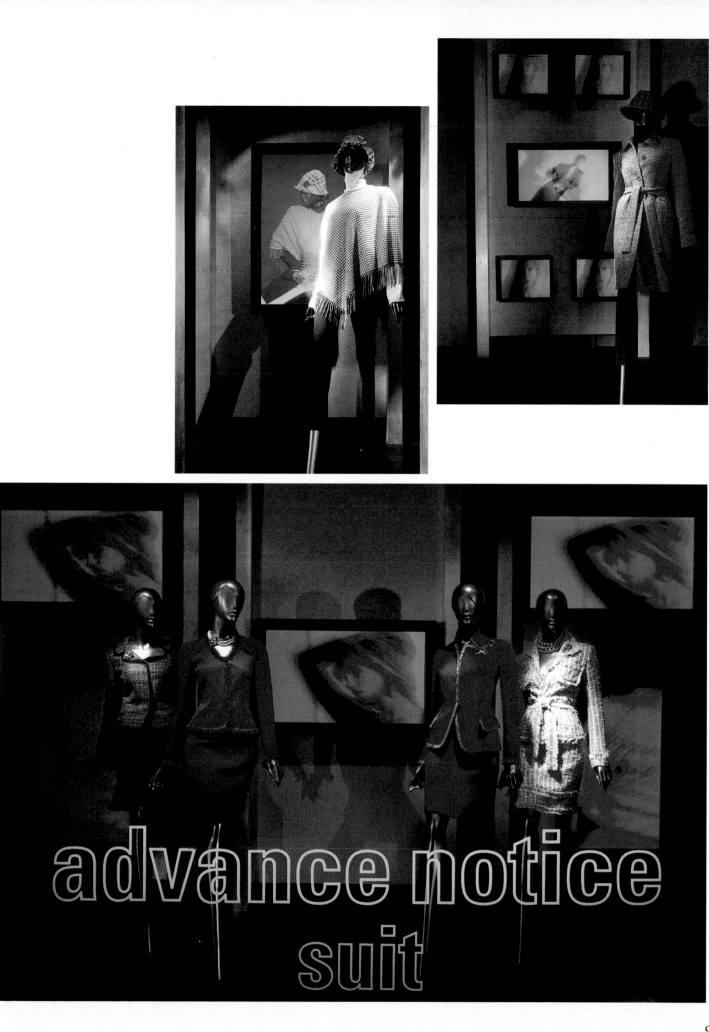

advance notice
suit

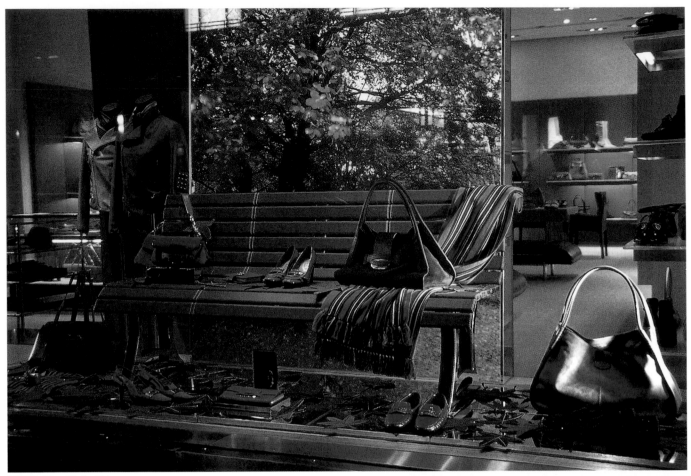

**TODS,** New York, NY

Falling leaves—leaves turning gold to russet to brown—and more leaves. That is how some New York shops introduced the fall fashions.

A photo blow-up of a tree, all rich in yellow, gold and orange foliage, sets the scene and serves to separate the display space from the shop beyond at Tod's. The park bench serves to raise some of the shoes and bags off the floor that is covered with colorful fall leaves. The green benches provide a sharp contrast to the red and blue fashion accessories.

The leaf-strewn floor at Coach creates the seasonal look and it appears that some of the leaves have been caught in the twists and turns of the wrought iron gate. The natural green and blue background says "out of doors" but sets no place—or time.

**COACH**
New York, NY

**VERTIGO**
New York, NY

Vertigo didn't miss any of the fall clichés to come up with this display. Together the elements create a textured and dimensional frame around the stylishly dressed mannequin. The red and gold leaves are contrasted with the branches and twigs while grapes and a fall harvest of artificial vegetables on a wood plank back up the mannequin.

Stylized, jewel-like leaves fill the background of Bendel's window that is filled with jewel-toned dresses and furs in which to make a grand entry into fall festivities.

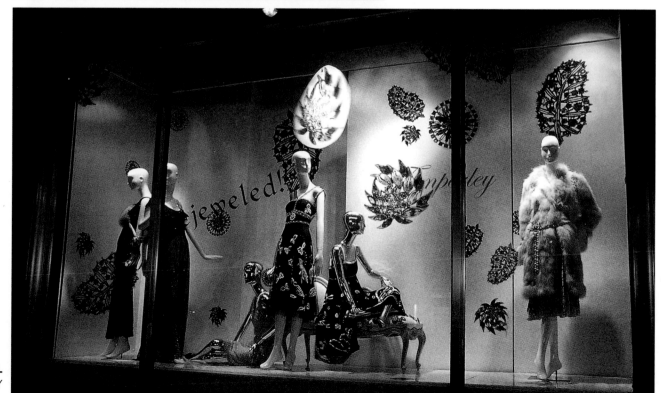

**HENRI BENDEL**
New York, NY

**CALVIN KLEIN,** New York, NY

Cutting back to the bare, bare textures of fall.

Bloomingdale's photo mural background is of bare, bare trees and even the leaves scattered on the floor are drained of color: back to basic, bare beige.

Calvin Klein cuts the season to the quick with logs and stripped branches against a brick textured wall. Here, too, the bleached leaves fill the floor.

The Crystal Shop in Munich has created a table of birch logs and added some bare branches as a "background." A fun touch: the cutting blades "sawing" the logs on the floor. All of this is in sharp contrast to the elegant and sleek crystal and glass shown on the rustic materials.

Diesel cuts the logs into slices and the slices become the background for the outerwear display. The rich, red/orange back wall further creates an autumnal feeling while the bare trees carry through the log theme

Bloomingdale's is barking off the tree to proclaim the new looks and colors for fall. Slabs of rough, brown bark appearing against the white back wall make a statement as does the garment shown in front of the dark textured plank.

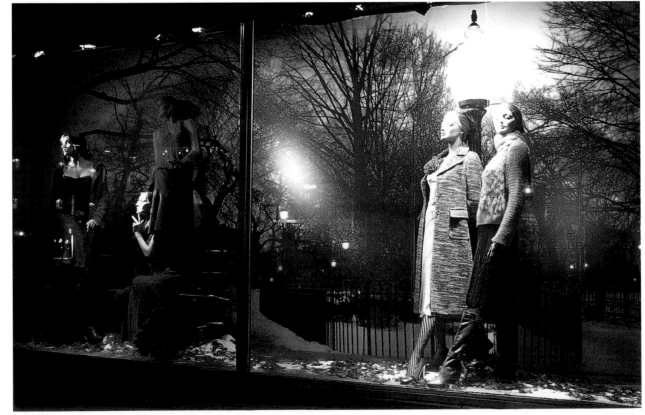

**BLOOMINGDALE'S**
New York, NY

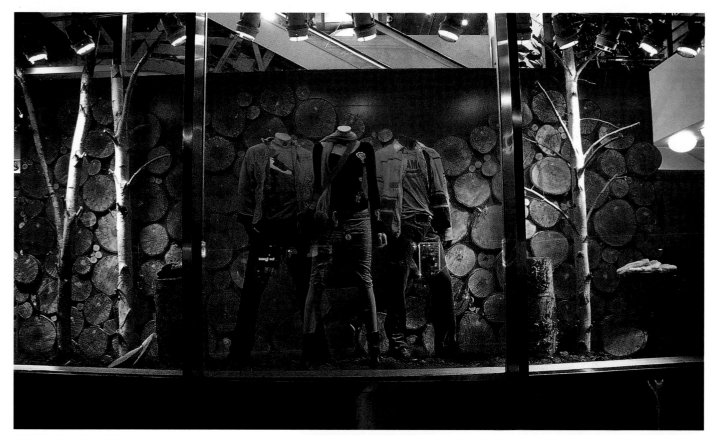

**DIESEL,** New York, NY

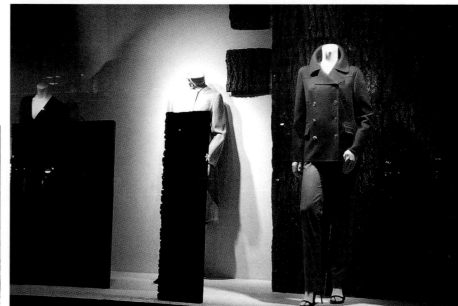

**BLOOMINGDALE'S,** New York, NY

**THE CRYSTAL SHOP**
Munich, Germany

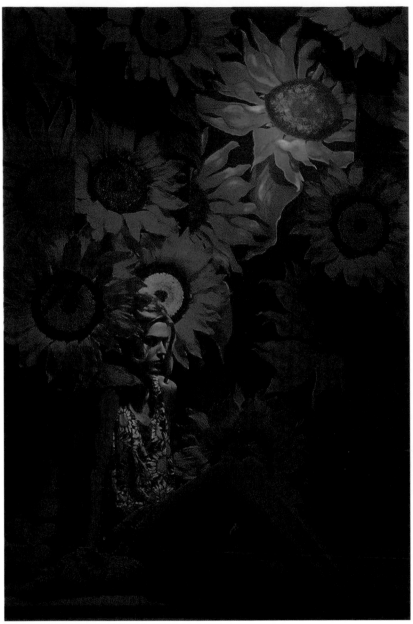

**PLACE ALEXIS-NIHON,** Montreal, QC

Etalage B Display, of Montreal, working under the creative direction of Constant Bibeau created these autumnal delights for some of their clients.

Sunflowers—really, really big sunflowers filled the windows and set the theme for Place Alexis-Nihon while in another of the shopping center's windows M. Bibeau tickled the season with feathers.

At Lunetterie New Look, fashion took center stage with this set-up created by Marie Eve Roy and Camelia Boamfa.

**ETALAGE B DISPLAY,** Montreal, QC
CREATIVE DIRECTOR: **Constant Bibeau**

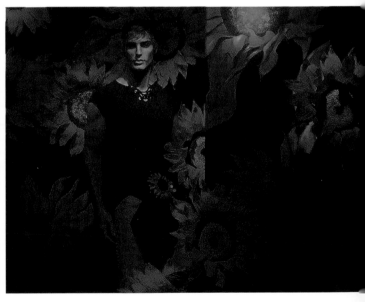

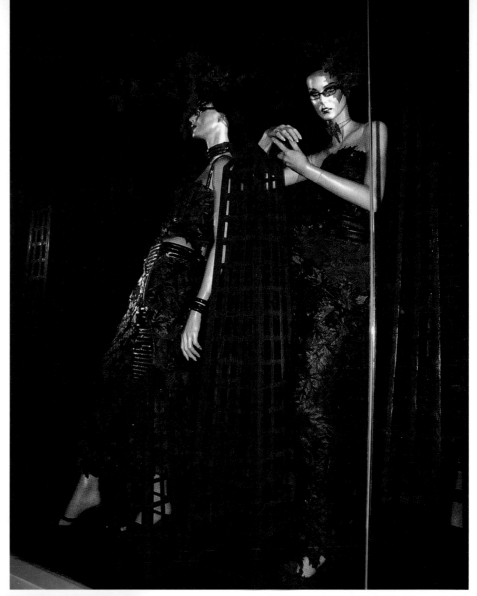

**LUNETTERIE NEW LOOK,** Montreal, QC

Payless
Shoesource
Le Château

**PLACE ALEXIS-NIHON,** Montreal, QC

103

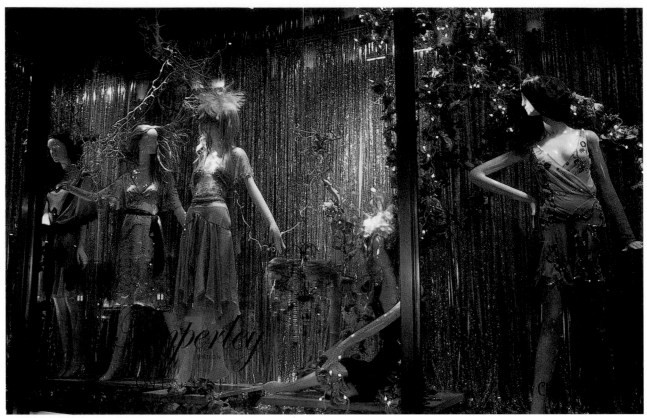

**HENRI BENDEL,** Fifth Ave., New York, NY

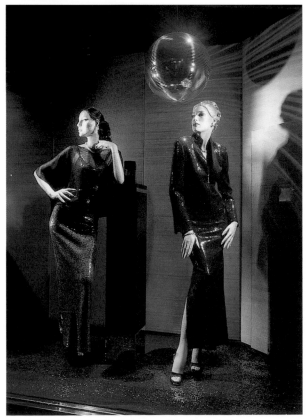

**ST. JOHN BOUTIQUE,** Fifth Ave., New York, NY

The fall season is the season for formal affairs. It is the season of galas, grand openings at the opera and the ballet, the theater season, and all sorts of dinner-dances. Shown here are some varied approaches to the presentation of formal wear.

It is party time at Henri Bendel and the tinsel fringe drapery, the glitz and glitter and the sparkle accented short gowns all say—"Let's Dance!" Bare branches and strings of bee lights and wind-swept wigs all serve to salute the fun and kicky fashions of Temperley of London.

St. John's "party" is much more subdued and restrained. The mirrored disco ball is reinterpreted by this spangled sphere that complements the shiny, shimmering sequined gowns on the realistic mannequins. Instead of spots of dancing lights reflected off the ball, the floor is drizzled with blue diamond dust.

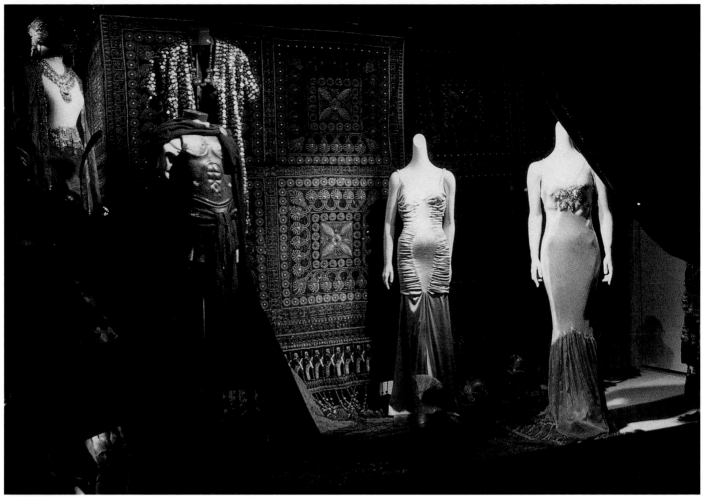

**BARNEYS NEW YORK,** Madison Ave., New York, NY

**EMPORIO ARMANI,** Paris, France

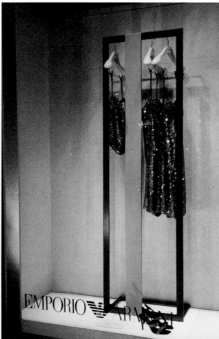

Barneys, as usual, goes all out and slightly over the top with their fabulous gowns set amid the panoply of ancient helmets, armor and a most unique tapestry. As a tie-in with the super-movie "Troy," the whole presentation takes on the feeling of a theatrical production as the draped red velvet curtain is pulled back to reveal the setting. This is a "grand opening."

And—for a change of pace—from the baroque (or the overwhelming of classic Rome) to the minimal. The windows for Emporio Armani, on the Left Bank in Paris, are as minimal as it gets. The props are squared off red metal clothes racks and the gowns are simply on hangers. As a complement —long scarves are shown in the next window: just as limply displayed. If the store is Emporio Armani—does it need say more?

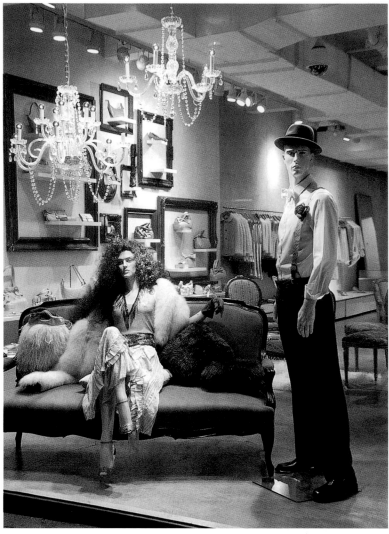

Chandeliers speak of elegance, drama, theater—of a more upscale lifestyle. They sparkle, shimmer and shine—send off rainbows of light and tinkling sounds. They set the scene.

At DKNY the chandelier hangs overhead in the open backed window and helps to set the scene with the addition of a few select pieces of furniture, a piece of drapery or an arrangement of picture frames on the side wall. The frames highlight a selection of fashion accessories.

**DKNY,** Madison Ave., New York, NY

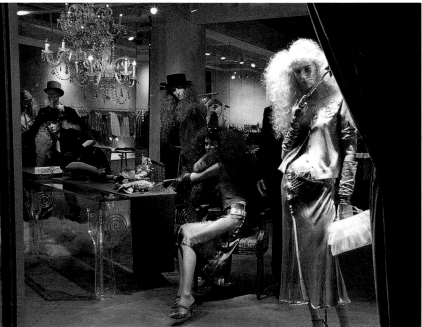

**BLOOMINGDALE'S,** Lexington Ave., New York, NY

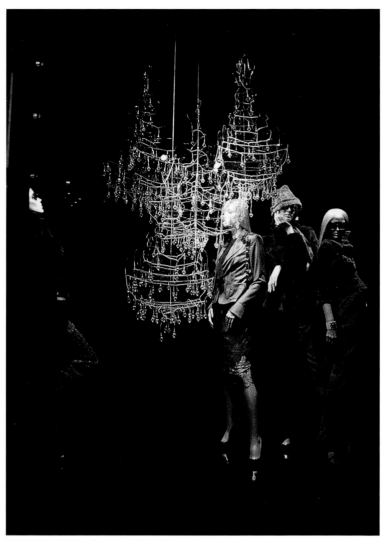

**ESCADA,** E. 57th St., New York, NY

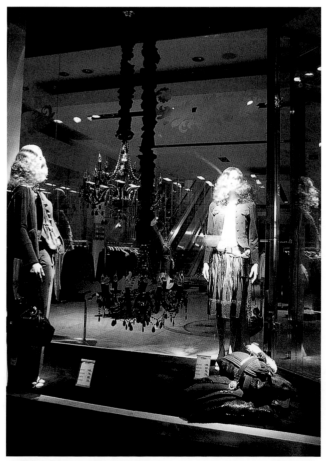

**ZARA,** Fifth Ave., New York, NY

Bloomingdale's black gown gains in stature—and attitude—as the chandelier repeats the shimmer and shine of the gown's beaded embroidery. Zara's chandeliers are black and mysterious but still manage to hold the two mannequins in a pleasing composition in the open back window.

Escada makes a more contemporary point of view on chandeliers with a cluster of spiraling metal lighting units from which red and clear teardrop crystals fall. They tie in with the fashions shown in black, gray and cerise. A novel look at how to do a Christmas window without the usual props.

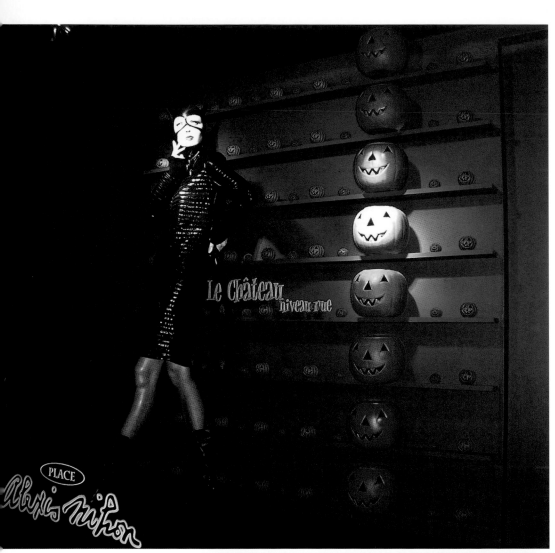

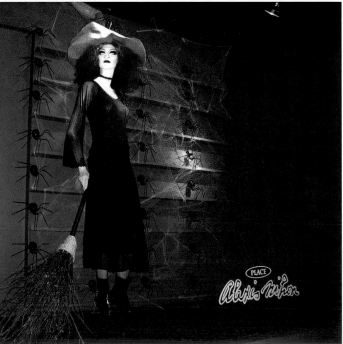

How do you pronounce Halloween in French? It appears that Halloween is Halloween no matter what the accent is but the prop accent is still on pumpkins, masks, ravens and spiders.

Etalage B Display of Montreal prepared these window presentations. For the Place Alexis Nihon, Constant Bibeau, the Creative Director, set the Cat Woman against a blue-violet infused setting embellished with horizontal shelves. Miniature jack o'lanterns line the shelves horizontally while larger versions make a vertical line-up to balance the mannequin in the shiny black outfit complete with Cat Woman mask and tail.

In another window it is a witch with broom that appears in a black chiffon dress and she is set to sweep away the spiders and the gauzy spider webs that are crawling over the back shelves in a rather orderly pattern. The man, in black and deep red, is backed up by black ravens (or are they crows) entwined with bare branches. Also bare is the umbrella he carries—open but defenseless against "The Birds"—think Hitchcock!

The pumpkin patch of weird and wonderful pumpkin-headed monsters was also designed for Place Alexis Nihon while the other cluster of pumpkins was created for a window at the Galeries des Tours.

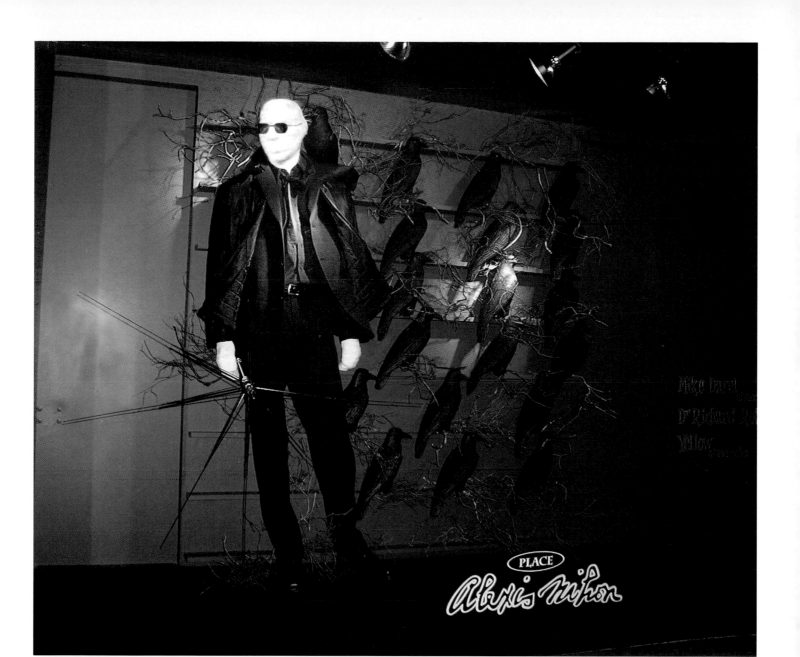

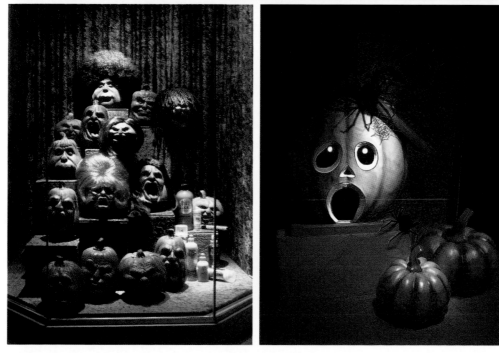

DESIGNS: **Etalage B Displays,**
Montreal, QC, Canada
CREATIVE DIRECTOR: **Constant Bibeau**

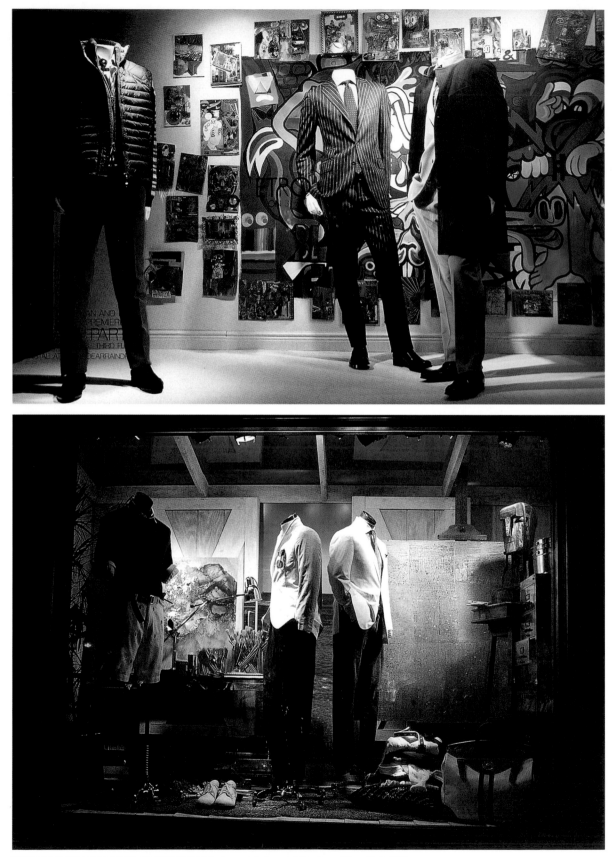

**BERGDORF GOODMAN MEN'S STORE,** (top and above) Fifth Ave., New York, NY

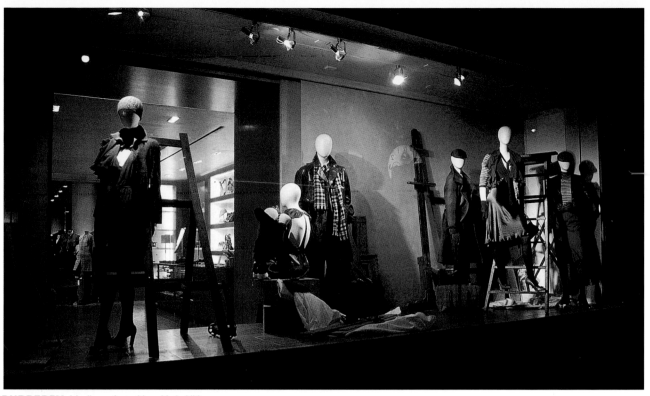

**BURBERRY**, Madison Ave., New York, NY

**CRATE & BARREL,**
Madison Ave., New York, NY

Lord & Taylor is not the only one that brings Fashion and Art together in their windows. Some other retailers do it by bringing paintings into the display—such as Bergdorf and Crate & Barrel—while others want to get into the art by gathering together the art supplies: easels, canvases, frames paints and brushes.

The brilliant colors of the cartoon artwork behind the Etro Collection in Bergdorf's Men's window are strong and eye-catching but the clothes still manage to stand out on their own. In a more subtle setting—blues predominating—the headless forms are interacting with paintings, easels and the array pf paints and art supplies used to set the atelier theme. The cool blue waterscape is visible through the open windows.

Crate & Barrel creates a "still life" in 3D and then backs it up with the painting to make a point. It is a truly effective technique and one that up-scales the Crate & Barrel retailer as a purveyor of fine furniture.

Burberry is getting ready to paint its own fall fashion scene. It has collected the easels, ladders, ornate frames, platforms—and stacks of canvases, The "models" are in place—all dressed and accessorized. They are just waiting for the "artist"—or is that the viewer on the street?

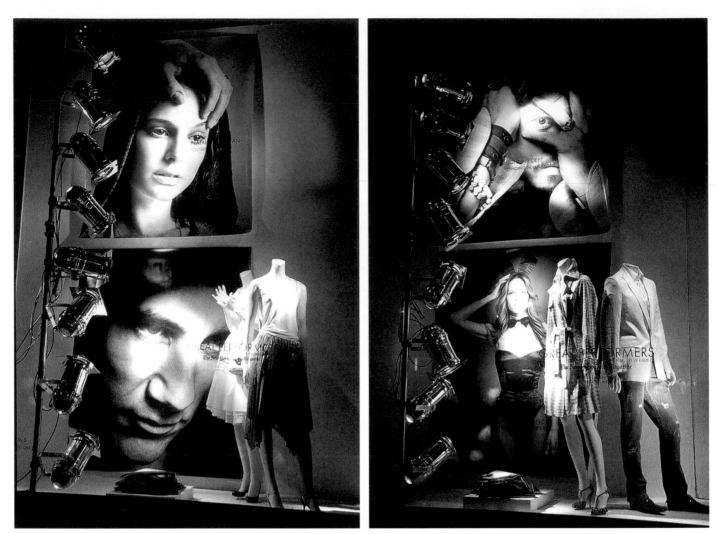

**BERGDORF GOODMAN,** Fifth Ave., New York, NY

Without lights there is no attraction—no color—no nothing! In addition to the incandescent sports and the low voltage halogen lamps display persons use to enliven and brighten up a window display, there are lights, lamps, lanterns and assorted lighting materials and techniques that can be added for extra sizzle or pizzazz to a presentation.

We begin with lighting fixtures: some high-tech—some sculptural—some easily recognizable for what they are and where they are used. For Bergdorf Goodman's "Great Performers" the addition of the shiny chrome spotlight holders and the big

black and white blowups of Hollywood celebrities reinforce the theme.

Chanel opted for a structural chrome framework to hold the open-to-viewing spotlights, and together they frame the headless mannequin while adding sharp accents of light to the outfit. It is almost like a rock concert abstracted. The assorted drums carry the accessories.

The fellows in Saks Fifth Avenue's window have just completed a "light sculpture" and they are still wearing their face shields that they used while welding it together. The violet washed back wall helps to create a low-lit ambience in which the assort-

ed light lamps can shine up.

Some mirrors, a contemporary chair and a standing lamp with chrome bubble bulb holders combine to create a modern setting for Faconnable's semi-realistic mannequins.

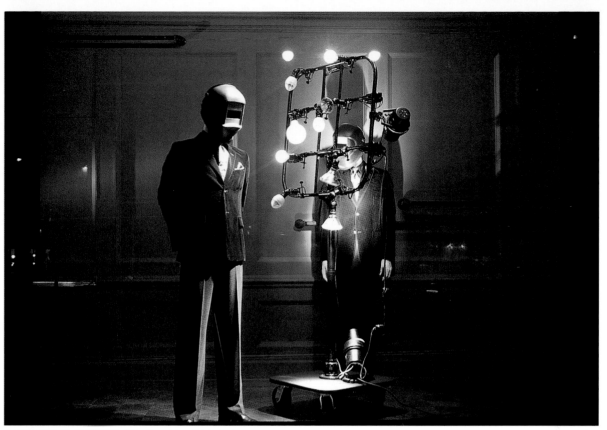

**SAKS FIFTH AVENUE,** Fifth Ave., New York, NY

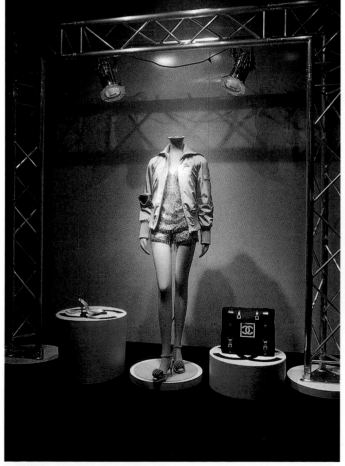

**FAÇONNABLE,** Fifth Ave., New York, NY

**CHANEL,** Fifth Ave., New York, NY

**BARNEYS NEW YORK,**
Madison Ave., New York, NY

Lanterns can be exotic—or just plain utilitarian. They can hang in a harem, light up a street, set a scene or just add some additional light. Barneys clusters a variety of mismatched, totally eclectic lanterns and lighting fixtures and suspends them from the ceiling to add sparkling light—and balance—to the asymmetrical composition. The jumple of lanterns and the tumble of chains and electrical wires add "mystery" to the display as well as capture the viewer's eye and pique her interest.

Bergdorf goes Asian—and Spartan—with these contemporary lanterns: glass cylinders encased in woven wicker mesh cages of Asian origin. They sit on a floor covered with shredded cork. The garments are draped on hangers that are attached to the "masonry" wall.

**BERGDORF GOODMAN,** Fifth Ave., New York, NY

**SAKS FIFTH AVENUE,**
Fifth Ave., New York, NY

**COLE HAAN,** Madison Ave., New York, NY

A single, ruby red lantern softens the chill of the cold blue setting for the abstract mannequin in the white gown that stands in Saks Fifth Avenue's window. It takes three brass lanterns, hanging over the oriental-style alter tables in the Cole Haan window to highlight the selection of shoes and bags being featured. Adding to the exotic and bazaar-like setting are the brass platters and servers.

Silk covered lanterns hang amid a flurry of feathers and plumes in the Tiffany shadow box. Asian crafted lacquerware is set out below and oriental seed pearls drip out of one of the lacquered containers.

**TIFFANY & CO.,**
Fifth Ave., New York, NY

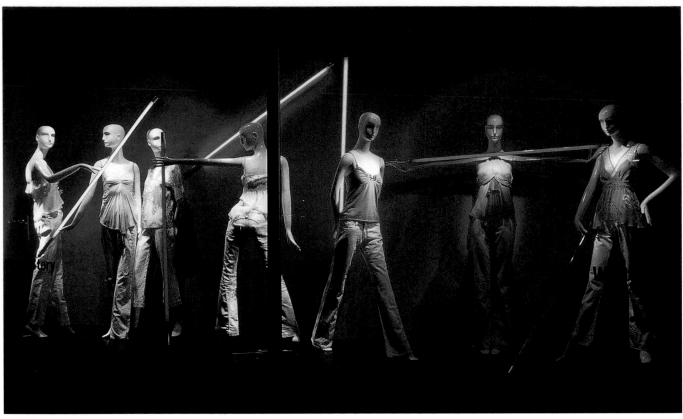

**BLOOMINGDALE'S,** Lexington Ave., New York, NY

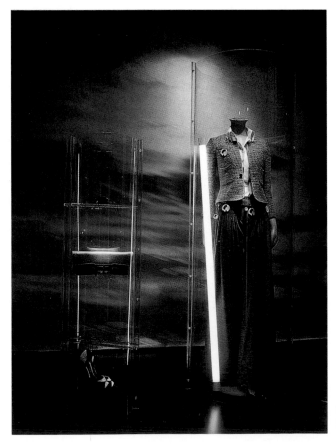

Neon and fluorescent tubes have their place as lighting props in window displays. Whether they are familiar signs all aglow in colorful neon or just bare fluorescent tubes ranging from two to six feet—cool or deluxe warm white—or sheathed in colored gelatins—they really put a buzz in the display.

Bloomingdale's has a low ambient light so that the fluorescent tubes—in assorted strong colors—can really put on a light show for the abstract mannequins wearing the many colored tops that contrast with the white pants. The dynamic angular lines of the tubes add to the sense of excitement and make this a real eye-catcher.

Strictly vertical! That's the line design in Chanel's window where a single illuminated tube complements the vertical line of the headless form in Chanel clothes. The Lucite fixtures, behind, carry a few special accessories while the figure itself is semi-enclosed in a half cylinder that reflects the tube's light.

**CHANEL,**
Fifth Ave., New York, NY

The neon tubing in Bendel's display has been bent and formed into decorative patterns that play up—in super scale—the detailing of the back pockets of the jeans worn by the mannequins in the window. They face the neon spectacular so that the viewer on the street can get a real good look at the hip pockets of the jeans.

Saks outlines in pink neon one segment of the backlit images that fill the back wall. If one looks carefully— the letters in the panel contained in neon spell out "MOM"—and that's what this is all about.

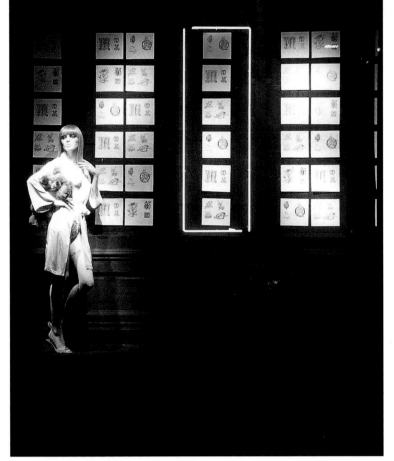

**SAKS FIFTH AVENUE,** New York, NY

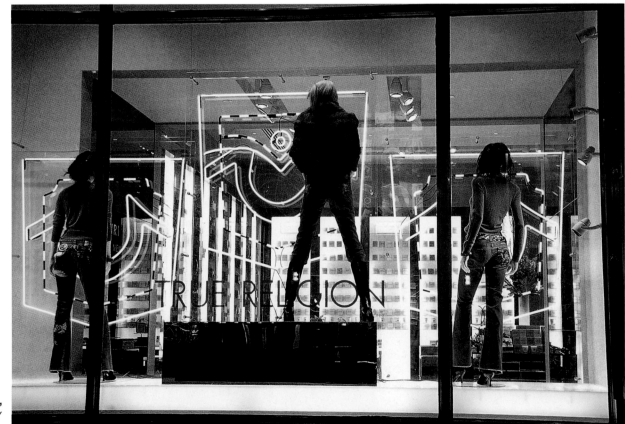

**HENRI BENDEL,**
Fifth Ave., New York, NY

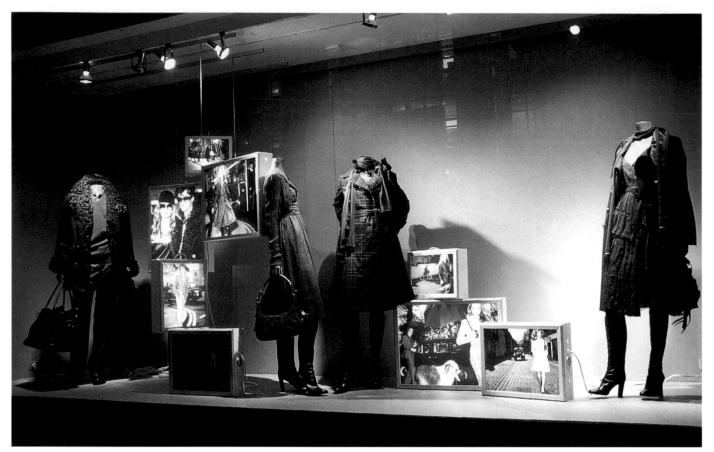

**BURBERRYS**, E. 57th St., New York, NY

Light boxes are all the thing in in-store graphics and in point of purchase—but how about as window display props? Here are some backlit/rear illuminated/ self illuminated panels/pictures that all add a sense of newness and excitement to the presentation.

Burberry's display combines two buildups or hand-downs of light boxes with black sand/white images of the "in" crowd doing in" things in the "in" places. This is all about lifestyle—the Burberry lifestyle.

A single flat plasma screen dominates the Henri Bendel window and it breaks up the mannequin presentation asymmetrically. The forest scene on the screen complements the bamboo rods balanced on the heads of the threesome while the single, on the left, uses her bamboo rod as a pointer—to the screen and the trio beyond.

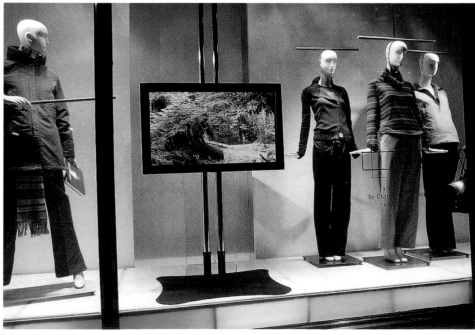

**HENRI BENDEL,** Fifth Ave., New York, NY

An X-ray? Why not get down to the bare bones of the message and here the message is Missoni. Barneys playfully turns an X-ray into a focal fashion display prop. Anatomy-like drawings are checkerboarded with squares of blue to create a diverting and amusing set up for the new Missoni outfits shown on the headless forms.

What else but a backlit screen is a computer monitor, and here, a laptop, in Sony's window it adds a bright touch of color—blue—in an all-white "George Segal"-like setting where the "sculptures" are all dressed in white or have been white-washed for the effect. And all to point up Sony's musical electronics.

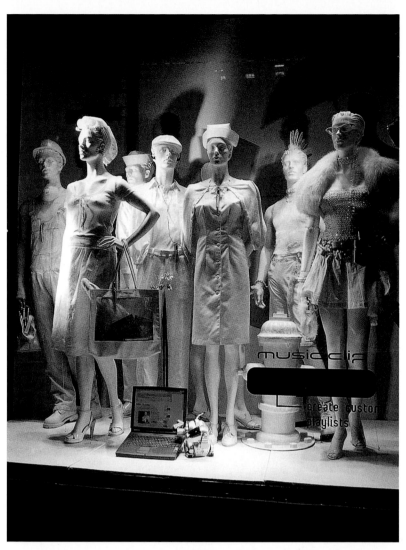

**SONY,** Madison Ave., New York, NY

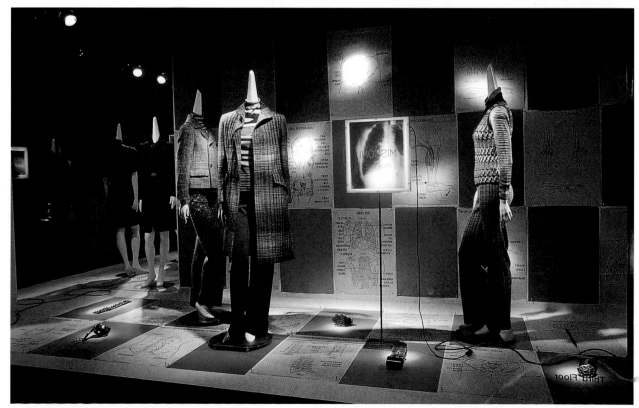

**BARNEYS NEW YORK,** Madison Ave., New York, NY

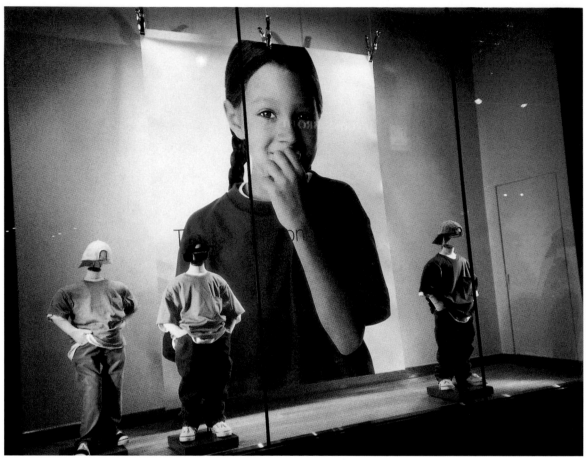

**THE GAP,** Michigan Ave., Chicago, IL

Accessories are small—usually—and can get lost in a standard display window. So, Bendel has resorted to a big statement in a big window to say something big about the small but vital fashion accessories. The lady up front really demands—and gets the attention she demands.

**HENRI BENDEL,**
Fifth Ave., New York, NY

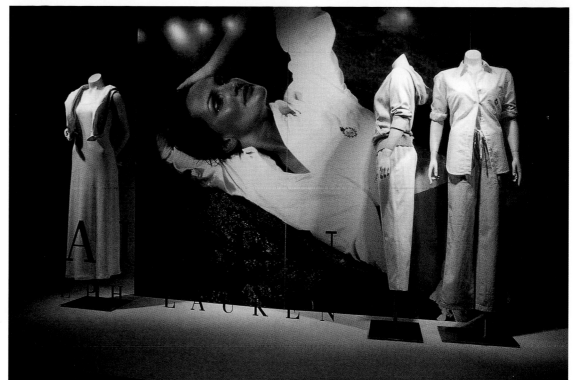

**MACY'S,**
Herald Square, New York, NY

Black sets off the white on white Ralph Lauren outfits featured in Macy's dramatic black windows. The giant graphic of the lady in white serves to relay the message.

Gucci goes black and white and wants everybody to know it. The graphics on the rear wall are "telling the world" what Gucci knows—and Gucci is featuring.

The big photo blow-up in Jil Sander's shop not only separates the window display from the store beyond but the bold yellow/black combination sends out strong vibrations while also providing a striking backup for the black dress.

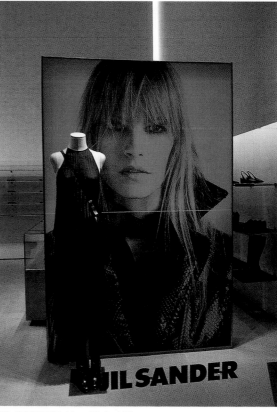

**JIL SANDER,** New York, NY

**GUCCI,** Fifth Ave., New York, NY

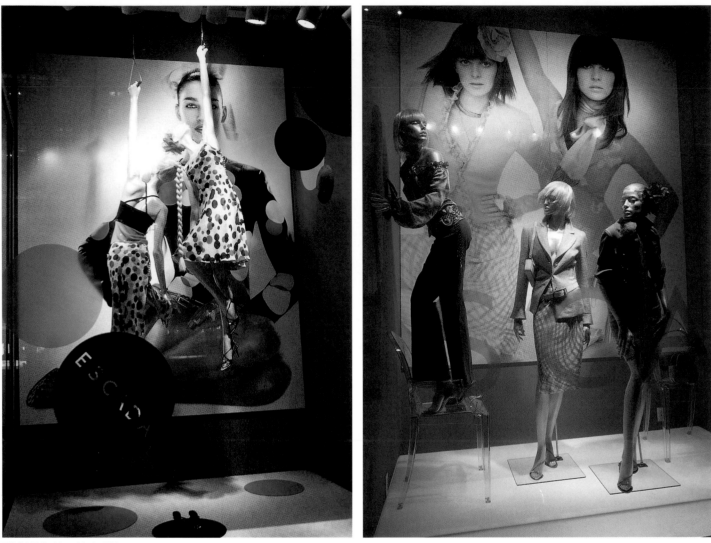

**ESCADA,** New York, NY

Picture this garment!! Now you see it in two dimensions—but big—larger than life size –bold and attention-getting from across the street. Now come closer and see the same thing—up close—for real—actual size and see how it looks on a three dimensional form or figure. The give and take, the yin and yang, flat and dimensional, picture vs. real—these all effectively showcase the featured garments.

Escada plays up the picture game with effective results. Illustrated here are three versions of the same approach. Notice in the pink/black dotted outfit—the dots come off the photo to become decorative elements on the floor and also carry the store's name. The pink garment, centered, is the "for real" version of the one on the photo left. The hot pink ambiance intensifies the pink story. The black/white story gets real sparks from the red that appears in the print and then is echoed on the mannequin's seat.

For the small lingerie shop in Colmar, France, the photo of the attractive model in the blue swimsuit really provides the sizzle for the rest of the display that features the same suit along with some auxiliary pieces.

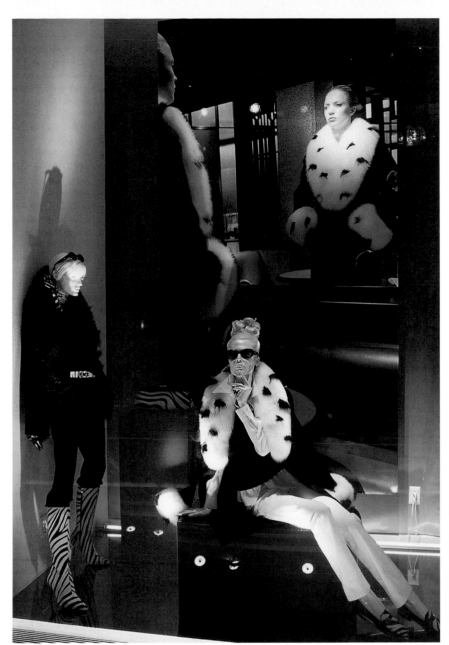

**ESCADA,** New York, NY

**CANELLE,** Colmar, France

123

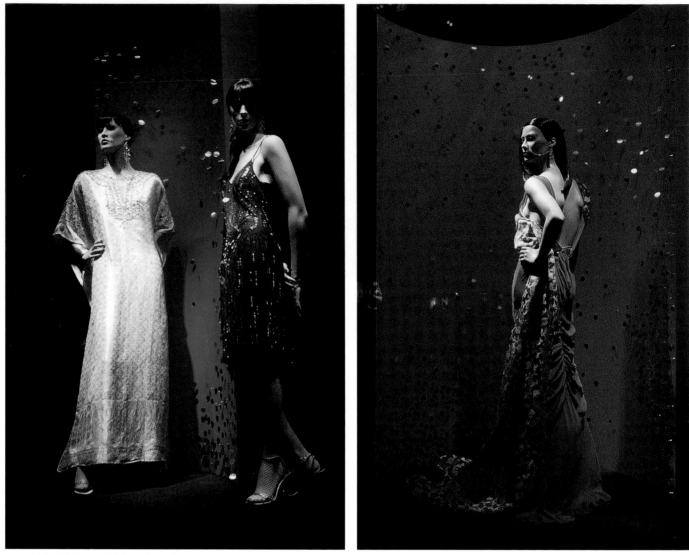

**SAKS FIFTH AVENUE,** New York, NY

Dozens and dozens of dots—circles—fill these window spaces. At Schreibmeister, Gert Mueller creates a fanciful background of assorted colored cardboard cut out circles collaged or layered and appliquéd. The dots flow out from the white square into the bold pink partition wall that serves to separate the window area from the store.

Sequins on strings drop in front of St. John's pink back wall to shimmer, shine and sparkle—as the strings move ever so slightly to the heavy traffic out on Fifth Avenue.

The pink back wall is a sharp compliment to the lime green outfit on the realistic mannequin.

At Saks Fifth Ave., their gowns are featured against curved partitions that are also enriched with strings of giant metallic sequins. Some of these dots are on strings and some are applied off the partition but they all add sparkle and drama to the gowns in front.

**SCHREIBMEISTER,** Munich, Germany

**ST. JOHN BOUTIQUE,**
Fifth Ave., New York, NY

125

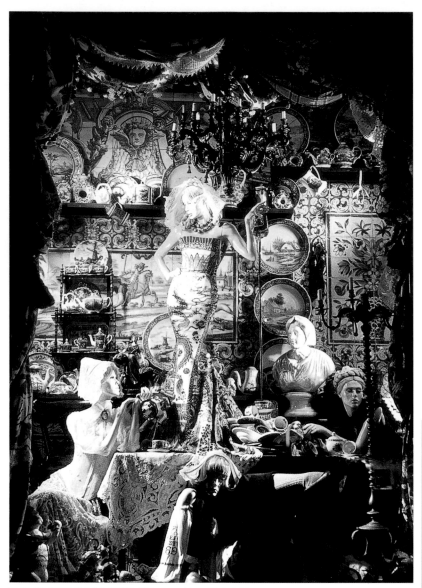

**BERGDORF GOODMAN,** Fifth Ave., New York, NY
VP OF VISUAL PRESENTATION/CREATIVE DIRECTOR: **Linda Fargo**
WINDOW DIRECTOR: **David Hoey**

The 35 windows of Bergdorf Goodman were filled with "fantasy dreamscapes" for this Christmas. According to Linda Fargo, BG's Creative Director, the windows "transport the viewer to exotic dream worlds featuring designer fashions, priceless antiques, zodiac mirrors, flying monkeys, gilded birds, Delft china, a zebra, an ostrich and a shop of curios—themed to a musical refrain from a cherished carol or holiday song."

"As I dream by the fire" is set with Delft china plates and an antique stove to complement the "Delft blue gowns" designed by Roberto Cavalli and Zac Posen. The stuffed zebra provided transportation for the jet beaded gown by Reem Akra in the "what fun it is to ride" window where the back wall was covered with black ostrich plumes. The opulent treasures of spices, perfumes and luxurious gifts introduced "bearing gifts we traverse afar."

The scene for "are you listening?" was set with priceless 16th century panels and the

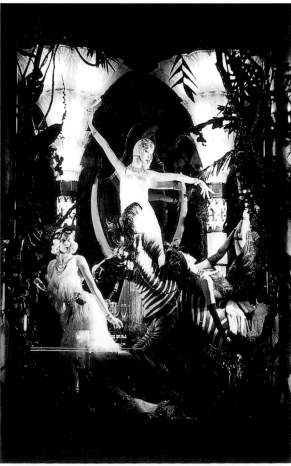

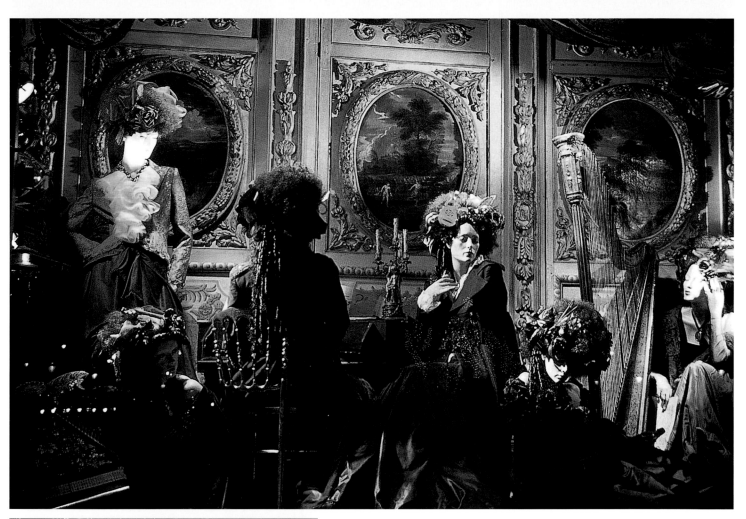

**BERGDORF GOODMAN,** Fifth Ave., New York, NY
VP OF VISUAL PRESENTATION/CREATIVE DIRECTOR: **Linda Fargo**
WINDOW DIRECTOR: **David Hoey**

mannequins wore miniature violins in their grand headdresses. A harpsichord proved the appropriate accompaniment. Venetian gold fabrics served as the backdrop for "three French hens, two turtle doves"—along with the gilded birds—and the opulent gown by Roland Nivelais.  Other refrains included "Deck the Halls" and "Star of Wonder" that centered around the limited edition UBICEF snowflake ornament. Other windows were based on "Do you hear what I hear?", "Star of royal beauty bright" and "12 drummers drumming."

**BERGDORF GOODMAN,** Fifth Ave., NY
VP OF VISUAL PRESENTATION/CREATIVE DIRECTOR: **Linda Fargo**
WINDOW DIRECTOR: **David Hoey**

Across the street—in Bergdorf's Men's Store—the refrains lingered on and "Jingle Bells" was now not about a sleigh but a bright shiny motorcycle to be ridden by a silver metallic horse. Horses appeared in the other windows as well.

"Our goal in producing these windows was simply to evoke the essence of the holiday: opulence, nostalgia, wonder and surprise.

**BERGDORF GOODMAN,** Fifth Ave., New York, NY
VP OF VISUAL PRESENTATION/
CREATIVE DIRECTOR: **Linda Fargo**
WINDOW DIRECTOR: **David Hoey**

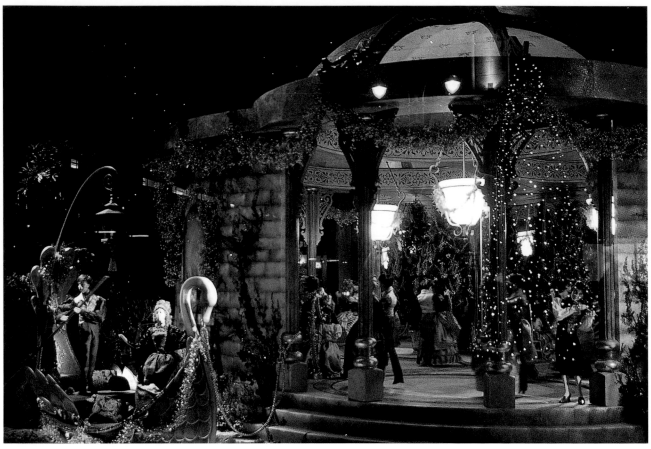

**LORD & TAYLOR,** Fifth Ave., New York, NY
VP/CREATIVE DIRECTOR: **Manoel Renha**

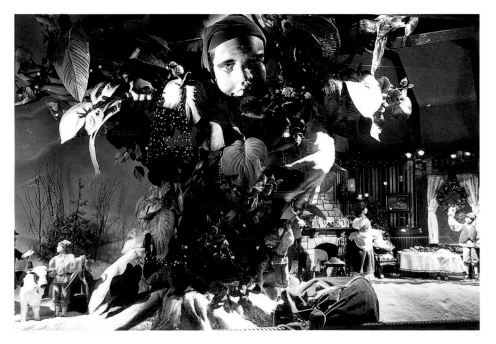

It was fairy tale time at Lord & Taylor where the favorite old stories our parents and grandparents grew up with were re-introduced to a millennial generation of cyber kids. It was once again—"Once upon a time" for beginnings and "happily ever after" endings.

And once again it was Manoel Renha, L&T's divisional VP/Creative Director who was at the helm in designing these spectacular animated windows that spread across the store's Fifth Ave. windows and drew long lines of parents and children waiting to see the "miracle" of make-believe. Again, the store's hydraulic lift windows allowed the space to be endless. The stories that came to life included "The Twelve Dancing Princesses," "The Princess and the Pea," "Jack and the Beanstalk," "Goldilocks and the Three Bears," "Rumplestilskin" and the ever popular—"Cinderella." Each window was divided into three scenes so with the brief copy provided and "filled in" by the parents who enjoyed visiting these old stories as much as the children—some meeting the characters for the first time—each story was told.

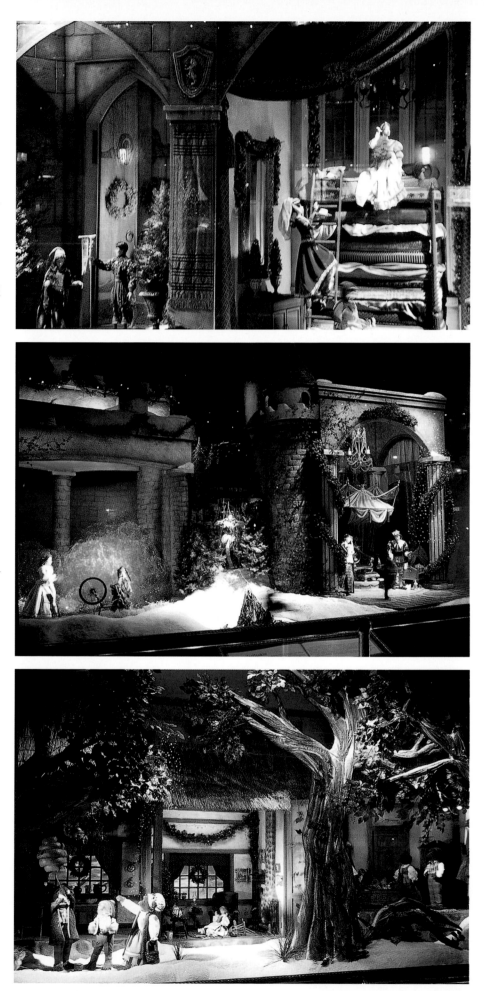

**LORD & TAYLOR,** Fifth Ave., New York, NY
VP/CREATIVE DIRECTOR: **Manoel Renha**

The "Once Upon A Time" theme was also carried through in the luxurious and opulent fashion windows. Here, the mannequins wearing the elegant gowns appeared as the life-sized princesses in some other fairy tales that included The Frog Prince and Rapunzel who could be seen letting down her long, long, long blond tresses from her tower prison. Scheherazade was there retelling her Tales of the Arabian Nights as well as the Ice Queen in her chilly, ice covered setting.

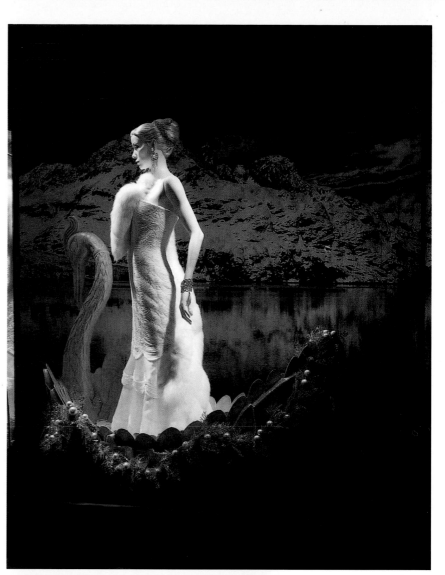

**LORD & TAYLOR,** Fifth Ave., New York, NY
VP/CREATIVE DIRECTOR: **Manoel Renha**

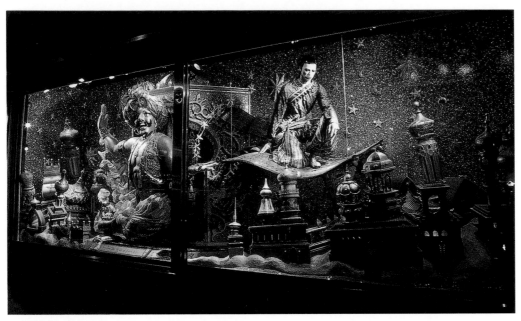

**BLOOMINGDALE'S**, Lexington Ave., New York, NY

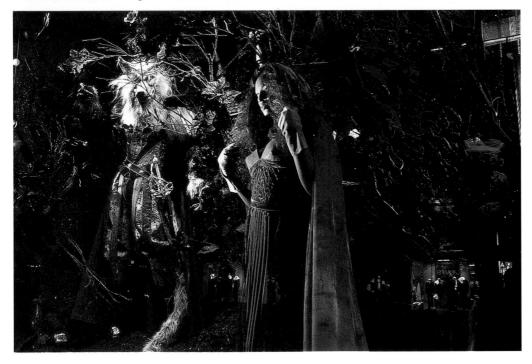

And—the stories continued on Lexington Ave, at Bloomingdales. Instead of the animated miniature figures that "told" the stories in Lord & Taylor's windows, here we had life-sized figures especially created by Donald Sanders, a noted theatrical designer, who wore the beautiful designer fashions. Here we saw sophisticated and sumptuous settings prepared for these almost life-like "princesses"—from Cinderella at the ball to Snow White to Rapunzrel standing alone in her tower with her long golden tresses just waiting to serve as a ladder for some daring Prince Charming.

For the more exotic tastes there was the Tale of the Nightingale and Aladdin on his flying carpet floating over a mythical Arabian kingdom against a jewel-like starry sky. The Frog prince also appeared at Bloomingdale's and here we see the Princess about to bestow a kiss on the bejeweled toad. The wolf looked like a fuzzy Puss-in-Boots

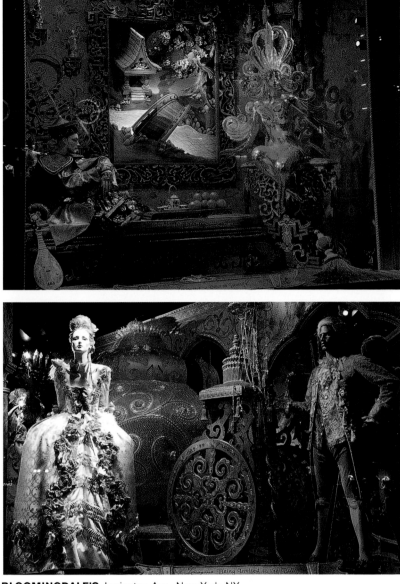

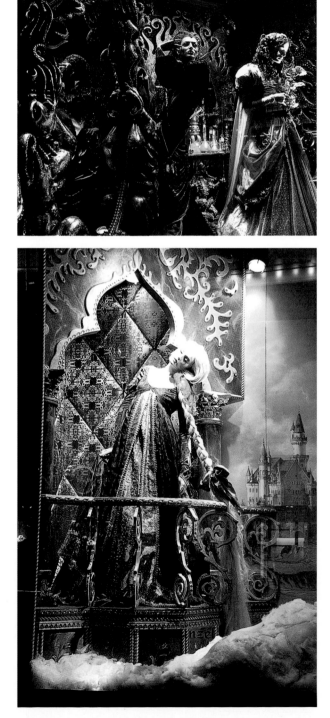

**BLOOMINGDALE'S**, Lexington Ave., New York, NY

but Red Riding Hood was resplendent in a red velvet gown. She wandered through a gilded and sequined forest. Cinderella tarried before her opulent gold carriage and one of her attendants awaited her decision. Will she or won't she? We all know how they ended up. We know that they will live "happily ever after."

Throughout, there was more "Sex in the City" fairy tales being told here than Grimm's. The beautiful designer evening wear was set off by the rich and beautifully illuminated vignettes.

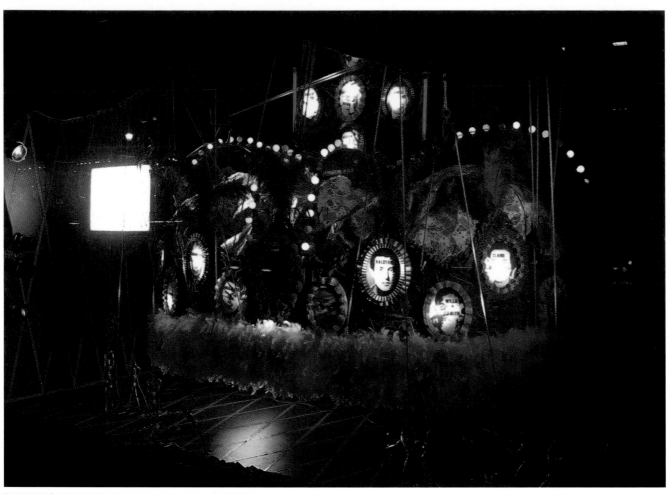

**BARNEYS NEW YORK,** Madison Ave., New York, NY
CREATIVE DIRECTOR: **Simon Doonan**

Simon Doonan, Barneys' Creative Director said, "This year we decided to give the windows the royal treatment they deserve." Well, it may not seem like the "royalty" you expected but it was "royalty" Barneys' way: full of fun, frivolity, and over-the-top and not necessarily in the Christmas Spirit.

The majesty of the crown followed through from the windows to the shopping bags and to the store's printed mailer—"filled with monarchial merchandise." This was a holiday—fit for a king or a queen. The five windows on Madison Ave. brimmed over—as usual—with more and more attention-getting details so that one really had to stop and study the nuances to fully appreciate the humor and spectacle. "They Hail from Queens" saluted, in caricatures by Greg Paxton, some of that borough's favorite sons and daughters. You could recognize Fran Drescher, Tony Bennett, Ethel Merman, Mario Cuomo and 50 Cent. Tribute was

paid to "The Label Kings & Queens of Yore": Stephen Sprouse, Pauline Trigere, Bonnie Cashin, Norman Norell and Adrian. A window-sized crown overwhelmed with jewels filled the window with the faces of the designers set into the crown.

"Get Royal, Get Regal, Get Real": with mannequins by Robert Grossman crowned with millinery by Rod Keenan, the viewers on Madison Ave. were treated to an "affectionate and satirical" look at Camilla and Charles of England. The walls were lined with tabloid headlines and teabags as well as framed "look-alike" photos of the Royal family by Alison Jordan.

For the "Kings & Queens" window the artwork was provided by children of East Harlem school. They painted "portraits" of the persons they felt were deserving of wearing the crowns. The portraits were sold after the display was dismantled and the money went to the school. The same Royal theme was carried out in the Barneys stores in Beverly Hills and Chicago.

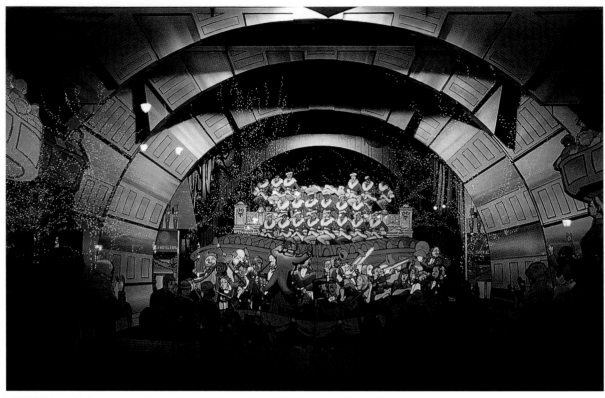

**MACY'S,** Herald Square, New York, NY
DIRECTOR OF WINDOWS: **Paul Olszewski**

Unfolding in five minute intervals were the over-scaled Pop-Up books in Macy's Herald Square windows. As each display unfolded with its own musical accompaniment, another New York City icon or landmark or must-see attraction came into three dimensional view.

There was the Radio City Music Hall's famous golden arched proscenium—arc after arc of golden rays with the orchestra rising up from the pit to accompany the Rockettes on the stage. And—any tourist would recognize the Rockefeller Center architecture and Promethius rising

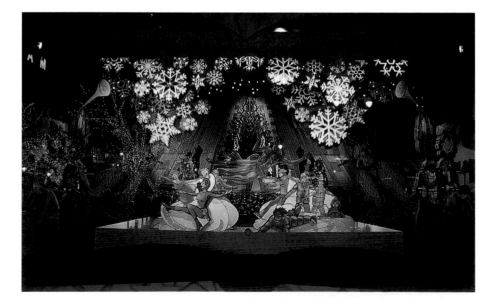

**MACY'S,** Herald Square, New York, NY
DIRECTOR OF WINDOWS: **Paul Olszewski**

up over the famous skating rink. Snowflakes fell all around this recognizable scene. Even if you were never in New York City for Thanksgiving, you would still know about or have witnessed the annual Thanksgiving Day parade from seeing it on television. Here were the myriad super-sized heroes, cartoon characters and icons as well as the stupendous floats. A parade floated across one of the windows in pop-up splendor.

There were windows proclaiming the color, glitz and pizzazz of Broadway, The Nutcracker ballets that are part of every holiday season—and, of course, the fabulous shopping of which Macy's is a big part.

The 2004 animated Christmas windows at Lord & Taylor—DELIVER THE JOY—celebrated the U.S. Postal Service's decades of delivering holiday joy through sleet, rain and snow. The six windows on Fifth Ave. told the "story" starting with Ben Franklin as joint Postmaster General for the Crown in 1773 in Boston Harbor, MA. The colonial setting showed the coffee house/tavern that was the typical mail drop for mail that was delivered by horse. By 1835 (window #2) mail was also delivered by steamboat and here a horse was shown being loaded onto the stern of a double-decker steamboat tied up at a dock in St. Louis, MO.

The stagecoach took over by the 1840s and window #3 showed a Colorado Rockies vista while in window #4 the view was of Hudson Valley in New York State in 1889 when steam locomotives were designated as postal routes. By 1920 (window #5) the biplane was seen soaring over a rural setting in Omaha, NE and mail was being sped up by these "cowboy" airmail deliverers. Window #6 showed New York City in 1930 when the mail truck became the common sight on streets and in this scene the mailman is at an art deco house that is being trimmed for the holidays.

The windows were conceptualized by Manoel Renha, Creative Director at Lord & Taylor along with the U.S. Postal Service. Each window depicted the method of mail delivery in a specific historical time and was inspired by an actual postage stamp that was enlarged and appeared in the upper right hand corner of each window.

This sort of turned the whole window into a giant holiday post card—sent by Lord & Taylor to its friends and customers everywhere.

According to Lavelle Olexa, Sr. VP for Fashion Merchandising and PR at L&T, "Lord and Taylor has been such an important part of the New York Christmas Experience that we wanted to give New Yorkers the opportunity to mail their holiday greetings from our own station." Thus, to enhance the "message" and to add more interest to the U.S. Postal theme, a special post office was installed in the New York store where stamps were sold, mail was stamped and the stamp designs that inspired the windows were available as greeting cards for sale.

**LORD & TAYLOR,** Fifth Ave., New York, NY

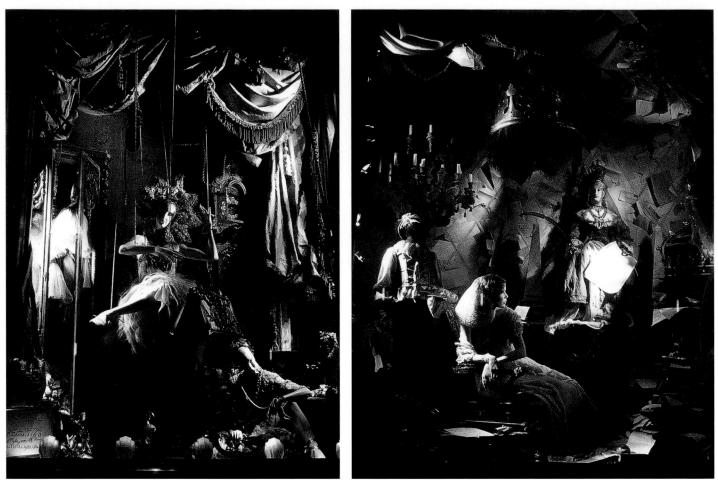

**BERGDORF GOODMAN,** Fifth Ave., New York, NY

Linda Fargo, VP of Visual Presentation was inspired to create these gorgeous, overflowing and overwhelming displays by some of her favorite quotations. These are quotes "that evoke emotions and sentiments associated with the holiday season" and they graced Bergdorf's windows for Christmas 2004. They were "a gift to the city, designed to spoil the viewer in a sensuous and delicious visual feast. Their rich fantasies aspire to invite the viewer into their world."

The window that was designed to represent an overindulgence in Chocolate was inspired by Salvadore Dali's "Beauty will be edible or will not exist." Dance was celebrated visually in another display that carried this message: "Love like you've never been hurt, dance like nobody's watching." The mystery of the masquerade window actually illuminated "When the wine is in,

the wit is out." For "It takes all sorts to make the world," the display depicted a cross-section of the earth—a view from the subterranean to the above ground and all size creatures between.

The inspirations ran from Dr. Zhivago to the Snow Queen of Hans Christian Andersen and there were cross references between literature, theater and art. All the sets were created in-house by the staff artists and "there is a strong sense of historical value with antiquities used as all of them are authentic and have come from the best dealers throughout the city." Linda Fargo and the Window Director, David Hoey, "wanted to capture Christmas in an emotional way, touching the celebration, warmth, and the spirit of this time of the year."

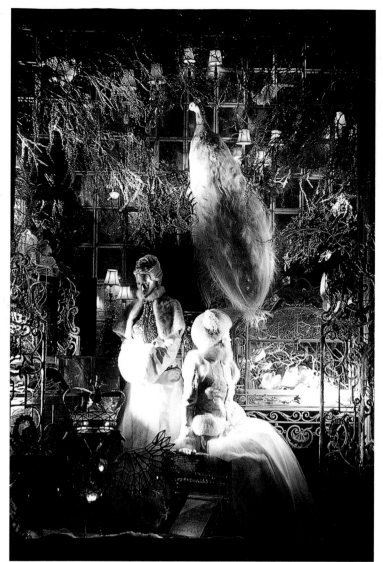

143

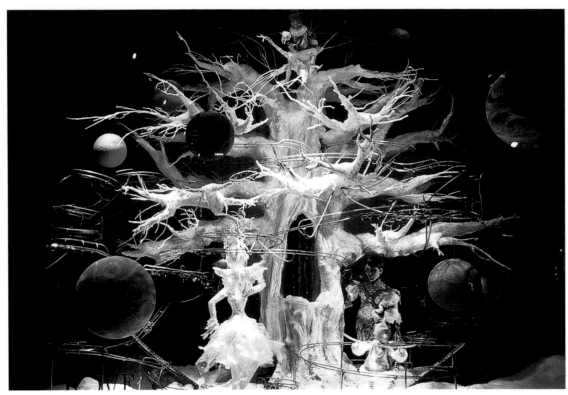

**SAKS FIFTH AVENUE,** New York, NY
WINDOW DIRECTOR: **Tim Wisgerhof**

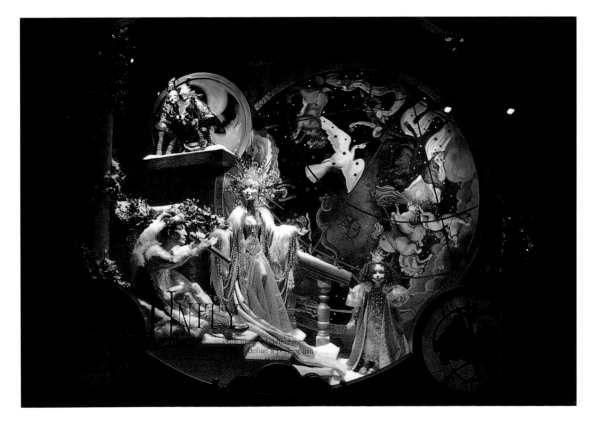

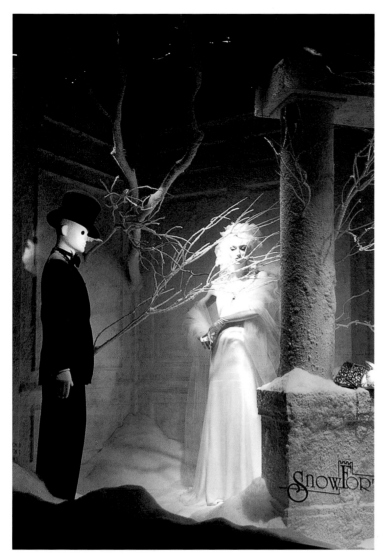

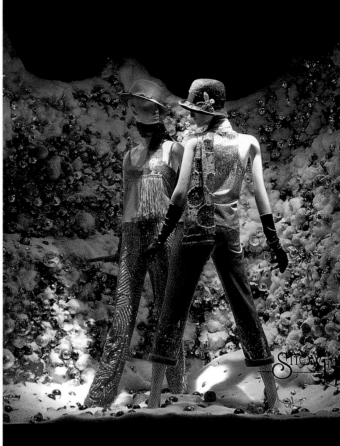

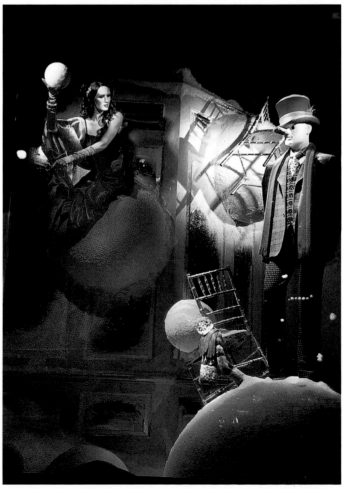

**SAKS FIFTH AVENUE,** New York, NY
WINDOW DIRECTOR: **Tim Wisgerhof**

Tim Wisgerhof further explained—"The windows (27 out of 33) explored the uniqueness of the word 'snow'—a whimsical romantic exploration of snow." Shown here are three of the fun "snow" words: Snowfall, Snow ball and Snow fort. In each case snow, snowflakes and fashion are combined to "make each window unique, as completely different expression, again reinforcing the utter individuality of each snowflake." Once again the Saks facade was enhanced with dozens of giant electrified snowflakes . These were introduced Christmas 2004 and were reviewed in our June 2005 issue of *Retail Design*.

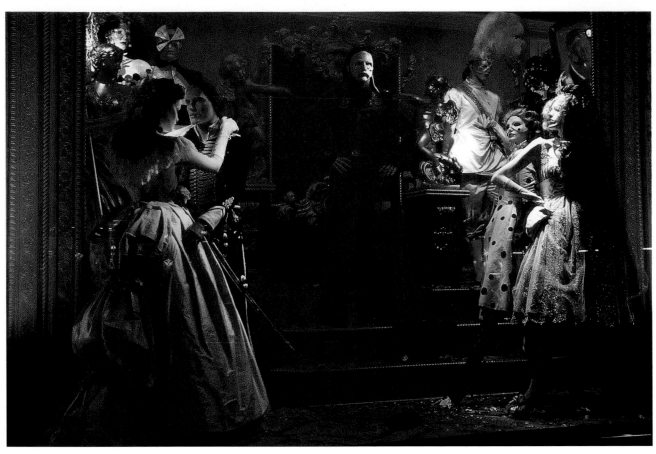

**BLOOMINGDALE'S,** Lexington Ave., New York, NY

Certainly *not* Santa Claus! No elves or reindeers! Not a Christmas tree or ornament in sight! No carols being sung! Instead—the sounds emerging from Bloomingdale's and washing over the crowds on Lexington Avenue —and the glorious sights and settings were all gift wrapped for visitors and native New Yorkers with a tie-in greeting from "The Phantom of the Opera" now appearing in theaters all around town.

Inspired by the new movie based on the musical play by Andrew Lloyd Weber, the Lexington Avenue windows "told the visual tale of this timeless love story using iconic images such as brilliantly lit, suspended Swarovski crystal chandelier, a red rose and a Swarovski jewel encrusted Phantom's mask. "The scenes/settings were enhanced with authentic set

décor and original costumes from the movie while on Third Ave. the fashions on display were "inspired by the opulence and romance" of the film.

Adding to the overall effect were

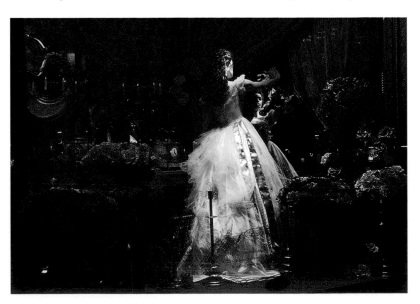

the rich, red awnings over the windows to create "a 19th century Paris Opera feel" and mounted, illuminated gold, arm-held candelabras lined the building on Lexington and Third

148

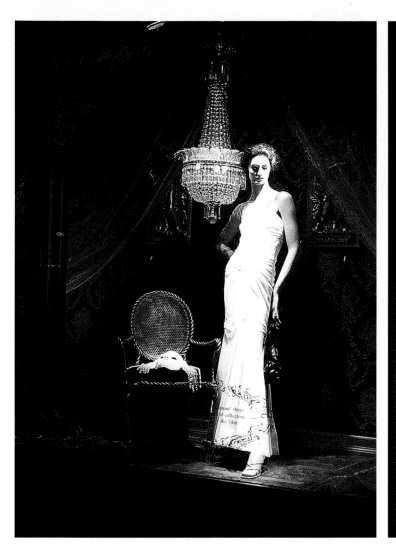

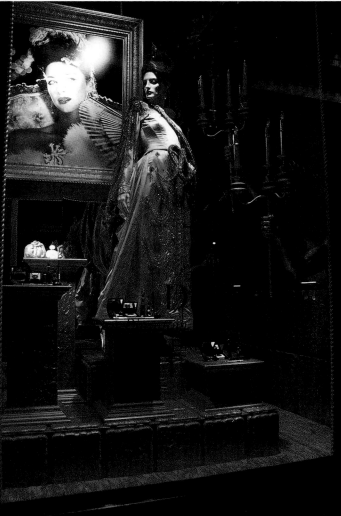

Avenues. The entire building was a "blaze of twinkling mini lights with an image of the Phantom's mask superimposed on the facade." To complete "the magical experience" the scent of roses floated on the air enlivened by the music from Lloyd Weber's score.

As part of the tie-in with the Warner Bros. movie, there was a gala window opening at which the director and some of the stars of the film appeared. Phantom shops in the store showcased ready to wear and special Phantom of the Opera tees were available along with the sound track of the film. "With their Phantom of the Opera holiday windows and exclusive Phantom shops, Bloomingdale's has captured the opulence, glamour, beauty and romance of the film perfectly," said Debbie Miller, Exec. VP Domestic Marketing, Warner Bros. Pictures. Jack Hruska is the VP of VM for Bloomingdale's.

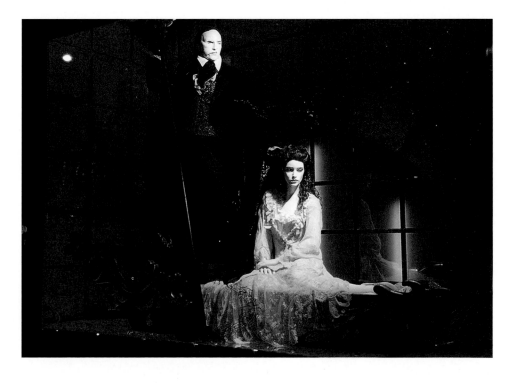

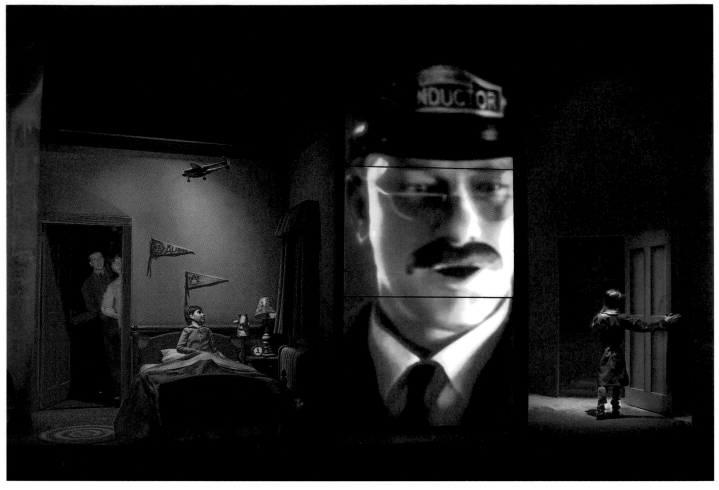

**MACY'S,** Herald Square, New York, NY

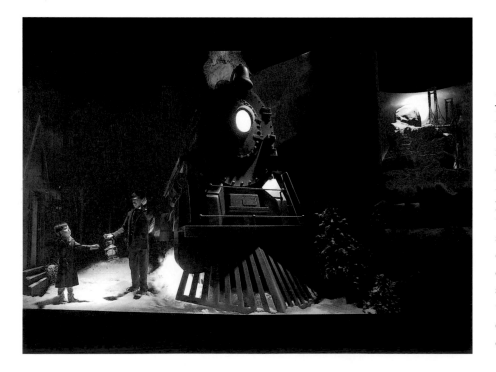

Just as the movie—"The Polar Express"—was about to pull out and arrive at cinema screens everywhere for the holiday season, it made its debut in three dimensions across Macy's Broadway windows. For youngsters and their parents who thrilled to the popular story, its appearance in the windows in a series of animated tableaux, was a sheer delight. Now they could see—in actuality—the same semi-real characters that peopled the movie. They could also follow the story from window to window with minimal copy

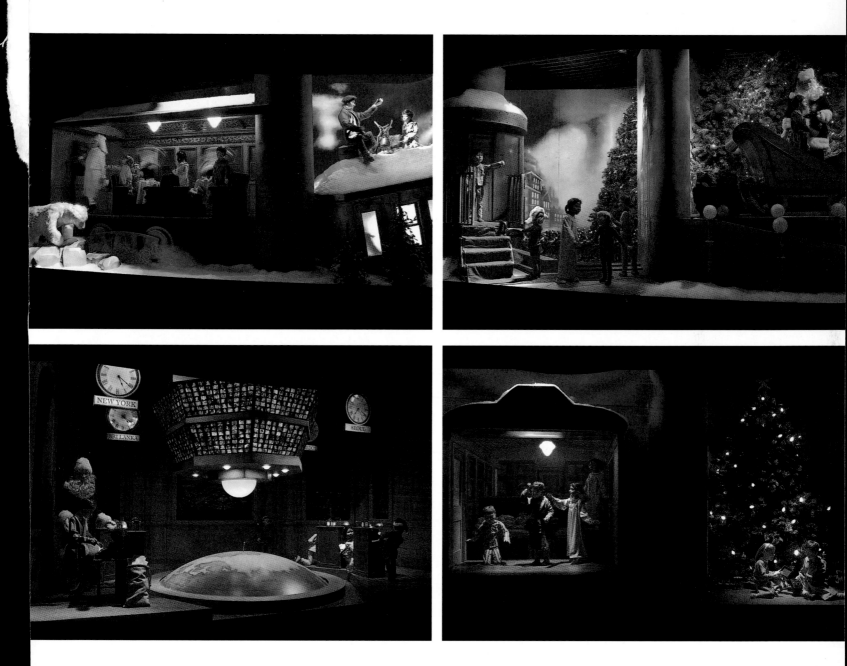

to provide the continuity while
music from the film filled the air. Of
course, the arrival at Santa's place was
the highlight of the story—and the
retelling in the windows.

Around the corner, on West 34th
Street, once again Macy's replayed
the "Miracle on 34th Street" animat-
ed displays that have become an ever-
popular tradition with Macy-ites.
Based on the 1947 film, the ever-
endearing and ever-enduring story
once again unfolded so that visitors
fresh from viewing The Polar Express
could once again soak in the warmth

and good cheer of this holiday
favorite.

With this Christmas display Sam
Joseph, the Creative Director, retired
after more than a decade of providing
New Yorkers and tourists with visual
delights and holiday treats they will
long remember. Bon Voyage Sam—
may your journey be a pleasant one.
We will miss you and your imagina-
tive creations.

**COLE HAAN,** Fifth Ave., New York, NY

The color of Christmas is RED! Red popped up and out of windows along the shopping streets of New York this past holiday season as it has for seasons before. There was red merchandise featured in the windows—red settings—red gift wrappings—and red lights to bathe everything in Christmas warmth. All in all there was a warm, rich hearty glow emanating from the windows that brought brightness and cheer to gray December shopping days.

DKNY covered their windows with red paper and red boxes and had lots and lots of red paper left over to fill in the open back windows and the

**DKNY,** Madison Ave., New York, NY

adjacent walls. Printed on the wall were assorted sayings about Love, Happiness and Health. Red covered panels carried the theme further into the store where they served as backgrounds for featured gift ideas.

Cole Haan went Asian with an elaborately decorated, cut-out elephant set against a rich red patterned background. The reds were teamed up with orange, cerise and gold and the gift suggestions were displayed in decorative cages suspended on shiny bead chains.

Sony's windows fea-
tured a variety of unique trees set against vivid red backgrounds. The perforated red metal tree was "decorated" with neon and TV monitors while the red sequined tree was surrounded by lap-tops and boxes tied with silver bows.

**SONY,** Madison Ave., New York, NY

153

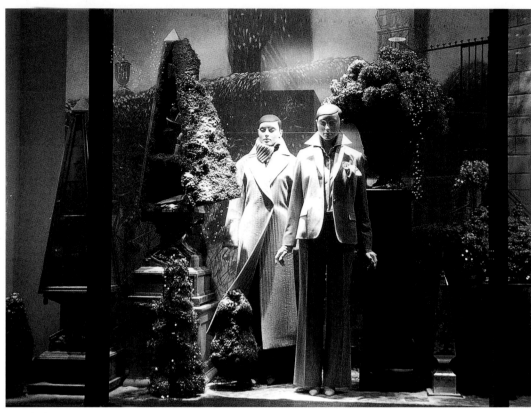

**FAÇONNABLE**

Holiday time brought out the traditional and non-traditional versions of the season's evergreen motif: The Christmas Tree. Made of plastic, wire, wood or acrylic—trimmed or untrimmed—realistic or stylized-green, white or metallic—in every which way but still recognizable, this cliché of the holiday took on new meaning as each store re-interpreted it to suit its own image and style of product offering. Here's to The Tree—long may it stand.

**PIERRE DEUX**

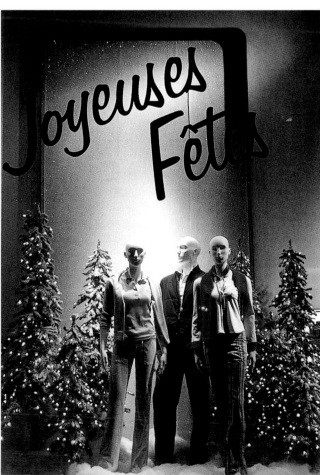

**LACOSTE**

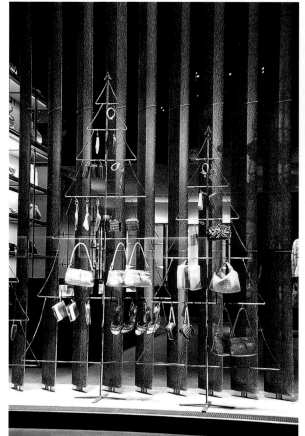

**BOTEGA VENETA**

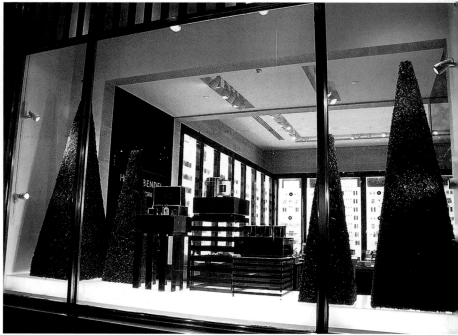

**HENRI BENDEL**

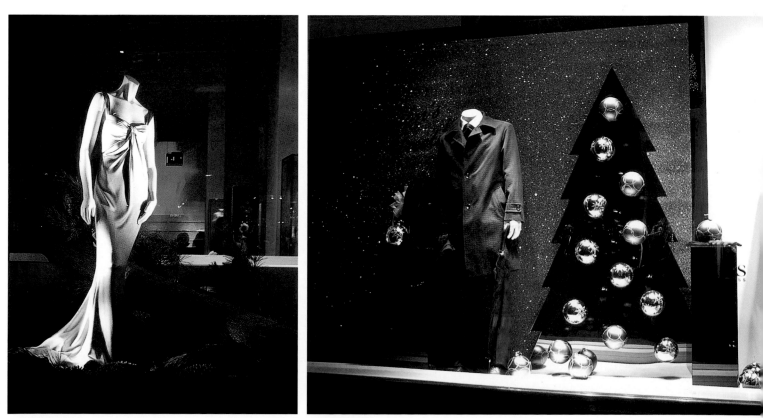

**CALVIN KLEIN**

**HUGO BOSS**

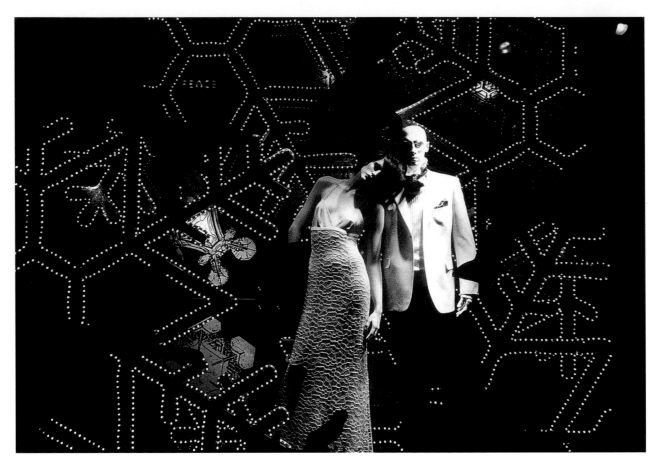

**SAKS FIFTH AVENUE,** New York, NY

While 50 gigantic, light filled snowflakes sparkled and sputtered to musical cues—danced, flickered and shimmered across the Fifth Avenue facade of Saks Fifth Avenue, the fashion windows below carried through the same, snowy, sparkling motif. Parts of the windows that showed off the stunning garments were masked off with branches or parts of the snowflakes while the backgrounds replayed the same light-filled snowflakes that appeared on the façade—but somewhat smaller in scale. The spectacle of lights within the fashion windows played out against a black back wall and was enhanced by the clever use of geometric shapes and forms with on-target lighting on the fabulous couture.

The garments on display in the Fifth Avenue windows were the creations of the six top award winning student designers of the senior class of Parson's School of Design in New York City. The windows on 49th and 50th Streets also featured more of the student designs that were fab-

ricated with textiles donated by the Italian Trade Commission. Furs were by Saga Furs and Swarovski provided the crystals that shimmered throughout.

For the mechanical windows, not shown here, the store showed scenes from "Santakid" in the five central windows. This is James Patterson, the noted mystery book writer's first book for children and the illustrations served as the template for the scenes shown in three dimensions. As a public service, Saks donated 10% of profits from the sale of Santakid themed products (mugs, ornaments, platters, etc.) sold in Saks stores during the holiday season.

The holiday Snowflake theme also appeared on the Saks catalogs, boxes and bags, and sold as ornaments in the store. Steven Wilburn is the Creative Director at Saks Fifth Avenue.

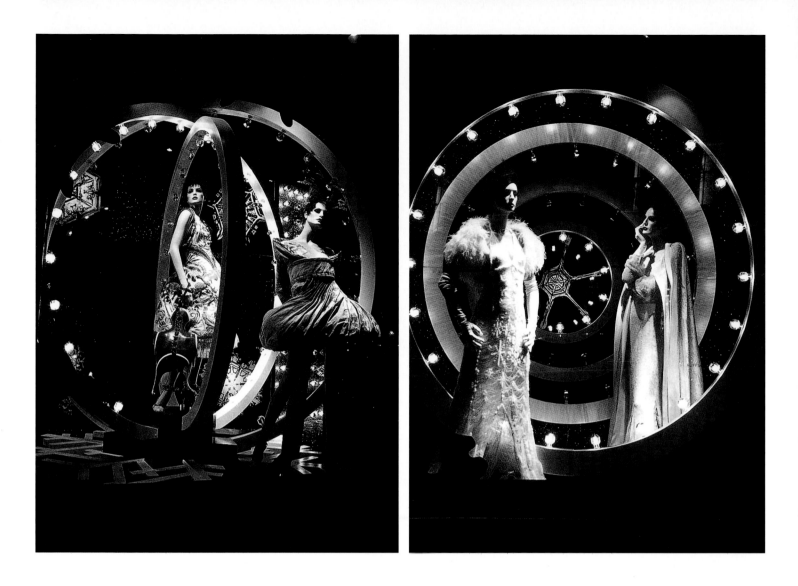

# Sale with Style

A sale is an event! It should be something special—something out of the ordinary—not expected. The sale should be a real occasion—maybe even a celebration. What a sale should *not* be—if this is a normal, healthy, functioning enterprise—is a distress signal: an S.O.S. that says "save our store because we are sinking." A sale is usually not an act of desperation but actually a realistic part of the business cycle when what is left must go to make room for what is coming in. A sale may be a promotional device in an arid time of the business year: a stimulant to bring in customers when they really aren't thinking about shopping or buying. Therefore, a sale needs as much planning and preparation as any other fashion promotion and please notice that the accent is on "fashion."

Unfortunately, too many retailers think that since a sale is usually combined with drastic reductions on merchandise, the shopper has to see the blood and gore created by the price cutting process. Too many have stored away in some closet a rolled up sheet of seamless paper with a desperate "SALE" scrawled across it in sanguine red. The sale officially begins when that tired, battle-scarred, and fly-specked banner is unfurled in the window. It also seems to be the cue to load up the window with a sampling of everything—EVERYTHING—that is on sale as though the shopper isn't astute enough to get the message. It was several years ago when a famous London department store for its January Clearance event turned its usually handsome display windows into a graveyard for sad, pathetic, forlorn mannequins crowded into the featured spaces—tattooed and polka-dotted with giant price tags. What didn't go on the lifeless bodies was relegated to pipe racks that were also jammed into the spaces. Really! Everybody knew about this sales event. It was a much awaited event and these tacky window did nothing to enhance the integral value of the sale merchandise or the store's fashion image. But things have changed. Today that January event is fashionable and smart—fun but refined—in keeping with the store's tradition and image and in recognition that the stores around it are doing their sales with style and panache.

A store's image—fashion or business—must be maintained at the time of sale-ing. If the store usually maintains a look of quiet dignity, taste and discretion, the sales event should maintain those same qualities. Dignity does not equate with deadly dull! For that store's clientele all it may take is a "gentle reminder"—maybe something graphic that says "out with the old, in with the new"—but never should the "old" infer something lacking in taste or value or something no longer desirable. The

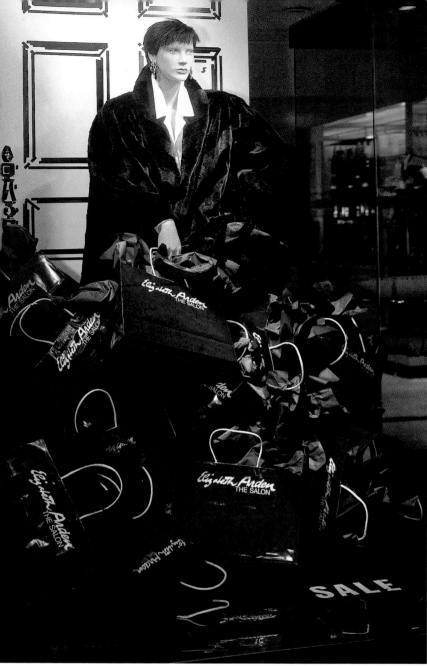

retailer is not "dumping" this merchandise, rather "moving it" to make room for something fresher. The message can be delivered with a well lettered, well situated sign or, depending upon the store's location and market, with something more humorous or amusing. Suggestions will follow. However, if the merchandise is bright, trendy and for the young-at-heart the displays can be more explosive—more fun—more daring and/or shocking—

more tongue-in-cheek. The display person can go a bit wild and over the top with startling presentations that get attention—and get talked about. But again, keep a sense of style with a sense of humor. A sale event should never be dull and repetitious. It is like the proverbial boy who cried wolf: nobody will believe the message if it is the same dull message one has seen year after year used in exactly the same dreary way. After a while not only doesn't the shopper believe the message, she probably won't even see it anymore because there has been no change in the presentation and "familiarity breeds disbelief." Nobody will look!

If the store has mannequins—real-

istic, abstract, anything in between—here are some ideas that might be adapted. "Everything Must Go," "Down to the Bare Essentials," "Stripped for Action": these could be the theme. For inspiration go back to "Eve" or "Lady Godiva"—or "Adam" with a fig leaf. She could be standing in her "all togetherness" but artfully given a G-Rating by how her long tresses are positioned. The long hair could for this occasion be made of yarn or colored cotton roping—or maybe even a stringy mop-head. Confetti streamer will also work. "Not a thing to wear?" Well, the store could offer a viewing of a few choice pieces maybe suspended off a limb hanging down in the background or

# VALENTINE @ THE BAY

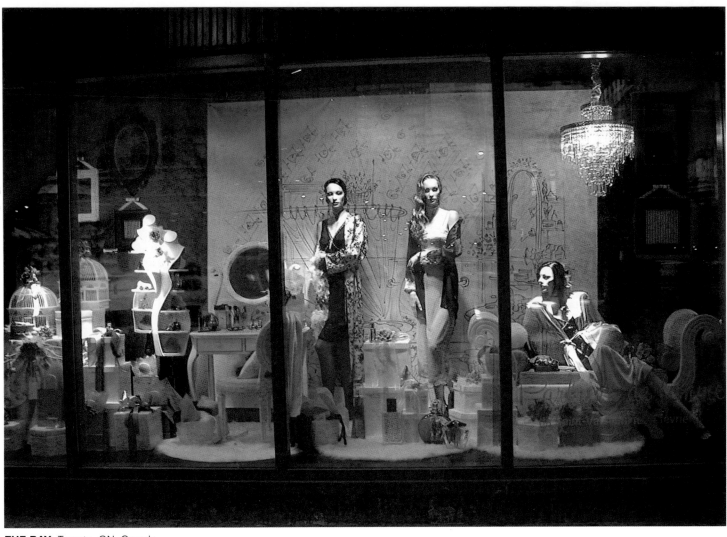

**THE BAY**, Toronto, ON, Canada
CREATIVE DIRECTOR: **Ana Fernandes**

Valentine's Day is an all-out day in retailing! It reeks of romance, sentiment and the sale of gifts for loved ones. The Bay, in Toronto, took full advantage of the after-Christmas doldrums and "blahs" that come with Clearance Sales to create these colorful, merchandise-full displays.

With room settings suggested in black line work on a white background, and some white-painted props such as chairs, tables, armoires, pier mirrors and chandeliers, viewers were invited to enter bedrooms, boudoirs sand private spaces where realistic mannequins and plaster of paris cherubs were surrounded by ribbons, roses and gift boxes filled with gift suggestions galore.

The caption on the front glass may have been in French, but the message of "love" and "giving" to one who is loved came through in the visualization.

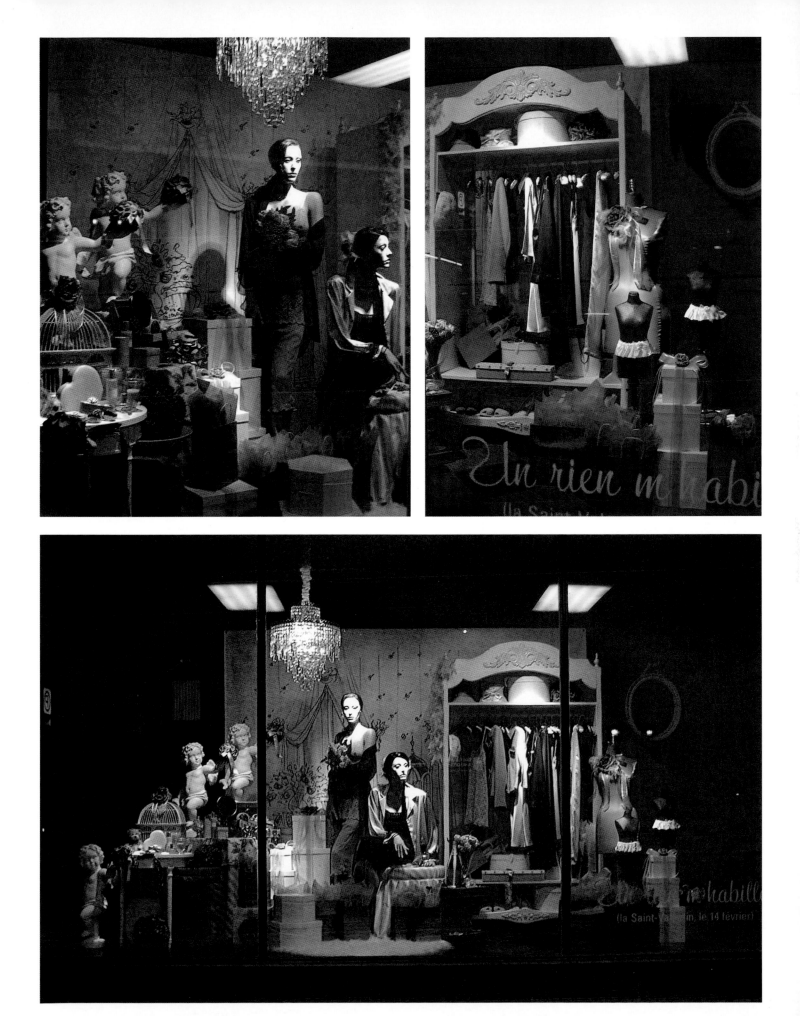

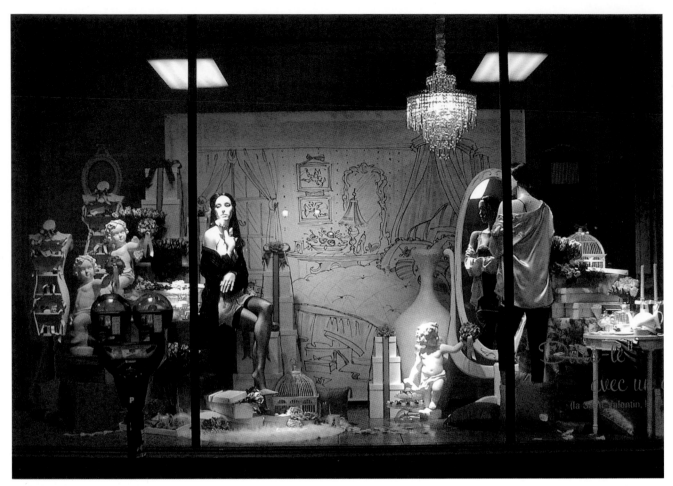

**THE BAY**, Toronto, ON, Canada
CREATIVE DIRECTOR: **Ana Fernandes**

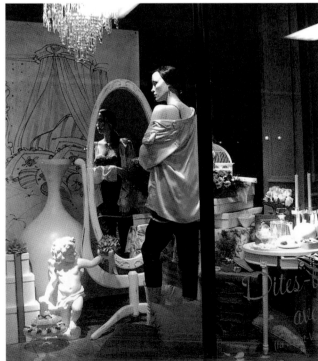

**MISS SIXTY,** Florence, Italy
PHOTOGRAPH: **MMP/RVC**

The Miss Sixty store in Florence, Italy broke out with these displays in honor of love—and fashion. "Love Hotel" is the vignetted setting for the romance and fashion show and, as the sign says, Lovers Only are welcome. Behind the semi-sheer pink curtains in the foamcore cut-out panel one can make out the silhouette of lovers.

In another of the small windows there is a giant hangtag around an overscaled door knob—and a message all about love. A fun idea—romantic and somewhat naughty and suggestive—but still so Italian in an American sort of way. All that was missing was an Elvis Presley recording played out on the street.

# VALENTINE A LA FRANCAIS

**PLACE DUPUIS,**
**PLACE ALEXIS NIHON**
DESIGN: **Etalage B Display,**
Montreal, QC, Canada

The designers at Etalage B Display of Montreal under the direction of Constant Bibeau created these displays for two of the many in-city malls in this bi-lingual city.

It was all about love and Valentine's Day in Place Dupuis and expressed in hearts and flowers. Hearts—hearts of all sizes, different colors and finishes and lots of red—told the story. In one display different hearts were "framed" in gilt and hung against a rich, red back wall as a setting for the festively-dressed figure seated below. In a menswear presentation, hearts were used as "heads" for the dress forms attached to the crimson wall. The male mannequin holds a bunch of red roses.

At Place Alexis Nihon there were butterflies and feathery boas to enhance the hearts as well as flitter and flowers. Especially effective was the dog bone heart for "man's best friend" in a shoe window. Not only were the "doggies in the window" a sure shopper stopper, the dog bones, leashes and rawhide chewys added to the fun.

Tiffany's Fifth Avenue, New York, shadow box windows were lined in red and the message of love was printed out on typewriters. Does anyone still remember typewriters? Using simple, familiar, everyday props such as pencils, pens, stationery and desktop accessories, a series of exquisite precious gifts were "tossed" in to the clutter for very effective Valentine themed windows.

**TIFFANY & CO.,** Fifth Ave., New York, NY

Tiffany's window, in Munich, as designed by Peter Rank, was all in white and signature Tiffany blue with the traditional cool pale blue gift boxes—tied up with white satin ribbon—covering a floating white foamcore heart. A suggested gift rests on the floor near a box with the ribbon undone.

Barneys went neon to highlight "V" Day —in this case Valentine's Day or "Victory for Love." You can tell that this is all about love because the "V" and the cut out "Day" are completely covered with white roses.

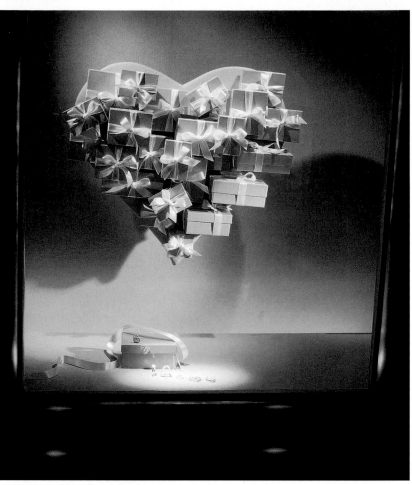

**TIFFANY & CO.**, Munich, Germany

**BARNEYS NEW YORK**, Madison Ave., New York, NY

169

**FORTUNOFF'S,** Fifth Ave., New York, NY

Giant, heart shaped cut-outs or masks set the theme at Fortunoff's and Nancy Koltes. The paper sculpture figures in the "ice cream parlor" setting are reminiscent of a Norman Rockwell period piece. They are surrounded by some of Fortunoff's silver and home gift items. Note the diamond ring the young man is hiding behind his back—to also remind shoppers that Fortunoff sells fine jewelry—and diamond rings.

Nancy Koltes gets the viewer to focus in on the garment suspended in her open back window by painting most of her front glass red with a heart shaped opening left to frame the garment and the pink polka dotted ottoman—with the bottom of the lingerie twosome resting on it.

Steuben Glass has a red heart in chains and locked up. But— they have provided numerous gold keys that can possibly undo the chains and free the heart. If the keys don't work—there is always the exquisite glassware on display that could make a heart more responsive.

In tall glass vials, red roses bloom from a floor strewn with white paper, cut-out hearts and some red ones that point up the choice bits of jewelry available at Objets du Desir.

**NANCY KOLTES,** New York, NY

Baccarat pulls back the dramatic red velvet drapes to reveal the shop beyond but—through lighting and propping—the viewer's eye is captured by the red roses, the chandelier and the Baccarat crystal gift ideas in red velvet boxes.

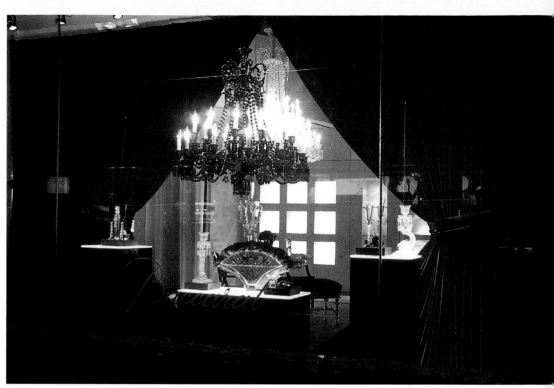

**BACCARAT,** Madison Ave., New York, NY

**STEUBEN GLASS,** Fifth Ave., New York, NY

**OBJETS DU DESIR,** New York, NY

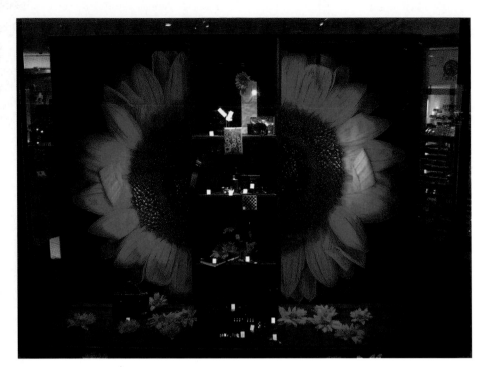

Wolfgang Gruschwitz, a Munich-based designer and educator, recently informed me about something called the AIDA factor in visual merchandising/display. The AIDA factor does not necessarily refer to an operatic or overblown window presentation. It doesn't have anything to do with Egypt, Pharaohs, Verdi or music. It is what it takes to do a successful display. As Wolfgang explained it to me, AIDA is an acronym for Attention, Interest, Desire and Action. A good display gets the shopper's ATTENTION, brings the shopper closer to bring about an INTEREST in the product and hopefully creates a DESIRE for it. Then it will lead to the ACTION of walking into the shop and trying it and buying it. That is what the AIDA factor is all about!

Gert Muller is a display designer working in Munich and he may never have met Wolfgang nor has he probably ever had the AIDA factor explained to him. However, he certainly knows how to use AIDA in the windows he creates for Schreibmayr,

located in the semi-open City Mall—5 Hoefe. It is an upscale stationery store set amid other up-market boutiques and smart cafes.

Muller learned his trade working for many years as a "window dresser" for a large textile and fabric store. From there he went to an even larger store. Before coming to Schreibmayr he created displays for Pelican (pens and ballpoints) and then did some time as a freelancer for Kaut

Bullinger "the biggest retailer in Southern Germany for office equipment." Kaut Bullinger eventually took over Schreibmayr and so Gert established himself as the creative director for this shop.

Working with small objects such as pens, papers, books and desk accessories calls for big, attention getting props and décor. Gert has mastered the AIDA factor: his display settings are attention getting and the interest is there in how he arranges the small individual elements into easy to see—easy to use clusters or groups. He must be arousing "desire" in the eyes and hearts of the Munich shoppers because the windows are producing the action that is making Schreibmayr so successful.

Gert Muller works on a 21 day schedule. On the 21st day the overture for another AIDA production starts up and the curtain rises on another new and unique setting for a

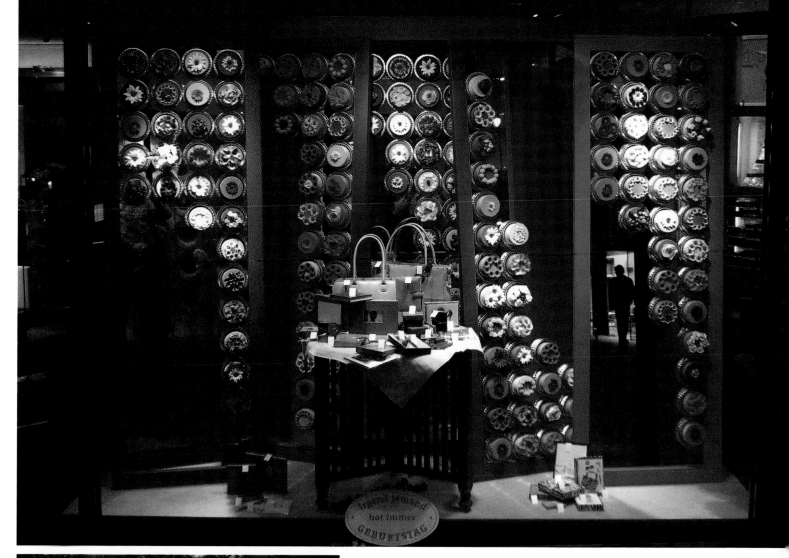

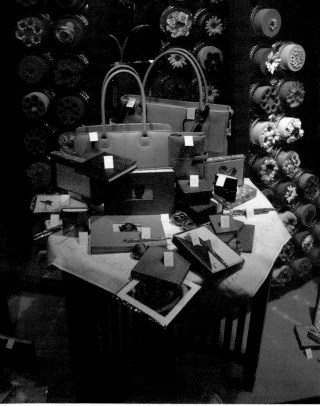

new set of characters (products). Sometimes his designs reflect a holiday—like Mother's Day—or a season. As Gert explains, "I selected the sunflower as an eye-catching device because of its shape and color. Usually my props are related in some way to the products that I personally select, but this time it was for an August window. We prepared customers for the early fall season when sunflowers are at their brightest."

Gert Muller very often makes his own props. For his "Birthday" window the theme was "Everyday somebody has a birthday." The idea being that Schreibmayr is a year-round source for gifts for anyone—of any age—for any occasion—and at any time of the year. The "cakes" were made of styrofoam and then trimmed with flowers that Gert had used in previous displays. The "cakes" were

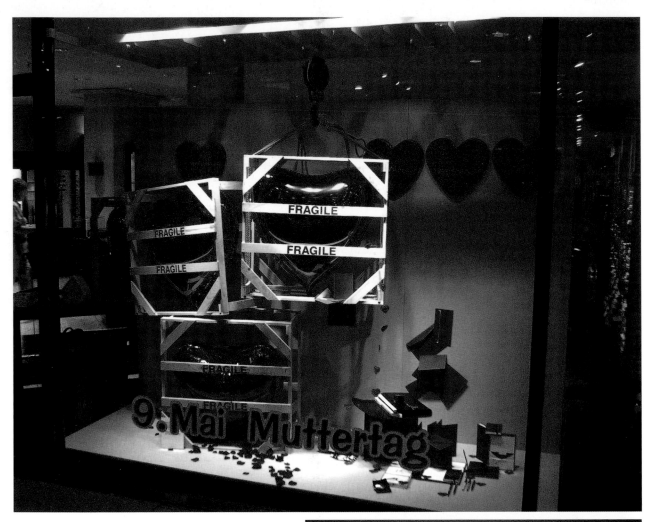

then glued onto the tin baking molds which were in turn "precariously" arranged—against gravity—on mirrored panels frames in pink. It was the many beautifully "iced" and trimmed cakes that caught the viewer's attention. Why cakes in a stationery store? The cakes brought them closer to see the arrangement of pink and lavender gift ideas arranged on a party table up front. Additional flowers were scattered amidst the coordinated items.

The Mother's Day theme of the heart within the crate, was inspired, Gert tells me, by something in saw in a *Store Windows* book. He gave it an all new look—and a new twist by using the inflated vinyl heart in the rough wood crates along with other red hearts against the stark white wall partition. The color scheme and the theme were followed through in the merchandise, artfully set off center on the white heart-scattered floor. To satisfy the "desire" and to get the desired "action," the same props were used inside the store with more products on display.

What looks like overscaled gumballs contained in vertical slots were not really meant to be anything. "They were just to be a three dimensional representation of movement, activity and fun. There was no connection—other than color—with the products on display. It was just a striking, flashy, eye-catcher."

Inspired by pictures of zebras that he had come across and the striking black and white patterns, Gert came up with his black and white window. The zebra photos made a central focus for a symmetrical window presentation and the zebra patterned poles to either side of the vertical run of pictures pointed up the black tables that supported the arrangements of the black and white products. The black background partition in the open back window effec-

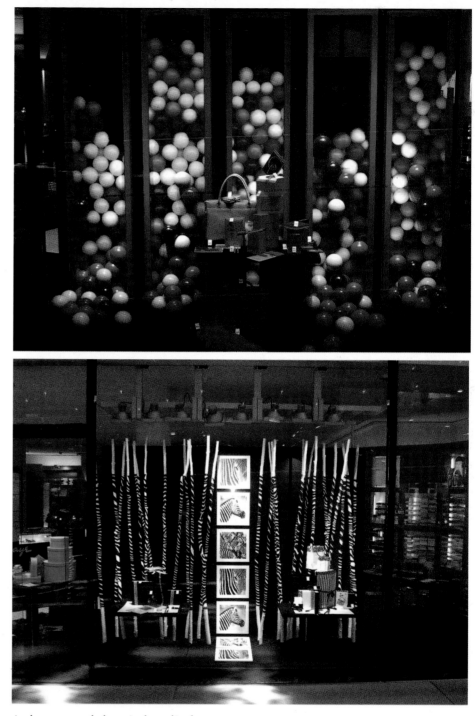

tively separated the window display area and its targeted lighting, from the colorful walls of product within the store.

Gert Muller promises to keep *Retail Design* up to date on his AIDA windows and we look forward to showing the readers more of them in the future. Thus, the curtain is coming down on this AIDA production—but only for an intermission.